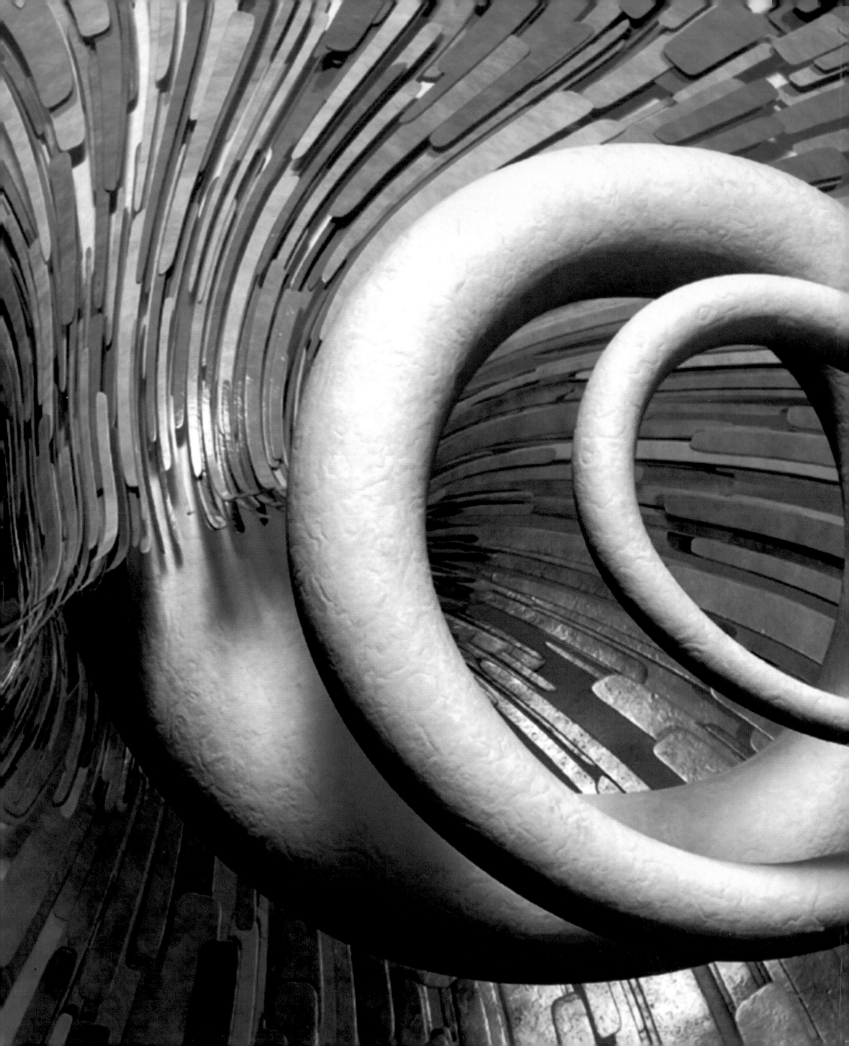

ART OF THE DIGITAL AGE

Thames & Hudson

First published in the United Kingdom in 2006 by
Thames & Hudson Ltd, 181A High Holborn, London WC1V 7QX

www.thamesandhudson.com

First paperback edition

British Library Cataloguing-in-Publication Data
A catalogue record for this book is available from the British Library

ISBN-13: 978-0-500-28629-6
ISBN-10: 0-500-28629-9

Designed by SMITH
Victoria Forrest
Printed and bound in China by C & C Offset Printing

**JOHN F. SIMON, JR., *ALIFE*, 2003.
SOFTWARE, MACINTOSH POWERBOOK G4,
ACRYLIC PLASTIC, 45.7 X 50.8 X 5.1 CM
(18 X 20 X 2 IN)**

CONTENTS

Acknowledgments

I dedicate this book to my sister Alice, whose encouragement and support over the years have nurtured my interest in art. I would like to thank David Rhodes, President of the School of Visual Arts, for his generous support of this project; Deborah Hussey and Maryalice Quinn, whose hard work, help and energy made this book a reality; and Joe Meyer and my graduate assistants Arlene Ducao and Ju Hyun Yoo, for their help with research and with the production of the book. Finally, I'd like to thank sincerely all of the artists who have contributed their work to this endeavour.

PREFACE

My involvement with digital art began in 1976, when I was a graduate student at Syracuse University. I was enrolled in an experimental studio course in which we created drawings by programming the university's mainframe computer. Although computer graphics were still at an embryonic stage, the potential of this new medium was apparent. The computer could draw with far more precision than the human hand, and the mathematical nature of programming offered me new conceptual and creative territory.

Over the past three decades I have seen incredible developments in digital art, and in recent years there has been a growing international interest in the art form. Digital tools have become ubiquitous, and the number of artists using them continues to grow. Several international art centres have supported digital art for many years, and an increasing number of museums and galleries around the world are now exhibiting this work.

The idea for this book grew out of the tenth anniversary celebration of the New York Digital Salon, established in 1993 to host an annual exhibition of digital art in New York and to foster an international awareness of art created with the latest technology. It is my hope that *Art of the Digital Age* will achieve the same aim: that by defining digital art through an overview of its history, its recent advances and many of most prominent practitioners, this book will serve to inspire those who have not yet begun to create in the digital realm.

Bruce Wands

AN OVERVIE W OF DIGITA L ART

Digital technologies have had, and continue to have, a profound effect on contemporary art and culture. Born out of the electronic revolution, the globalization of mass media, and the internet, digital culture holds even more potential for societal change than television and radio once did. Whereas television and radio are broadcast media and provide only one-way communication, the internet offers the opportunity of interacting with others and allows access to a far greater range of information. We are at a time of unprecedented growth and innovation in the world of digital technologies, and the place of digital media in contemporary society and in our daily lives has been firmly established.

Contemporary artists are using the internet as a new art medium and adopting digital tools and techniques as part of their creative process. The computer has enabled artists to create works, and new types of work, never before possible: intricate images that could not be created by hand; sculptures formed in three-dimensional databases rather than in stone or metal; interactive installations that involve internet participation from around the globe; and virtual worlds within which artificial life forms live and die.

As the boundaries of digital art expanded during the mid-1990s, museums began to take a serious interest in its development. Significant exhibitions of digital art have been held in recent years, showing its increasingly widespread acceptance throughout the contemporary art community. In addition, museums and galleries are bringing their collections of traditional art online, making them easily accessible. As a result, the role and presence of art in society is undergoing considerable change and growth. The art experience extends now to homes, cybercafes and any public or private space where there is internet access or a local area network.

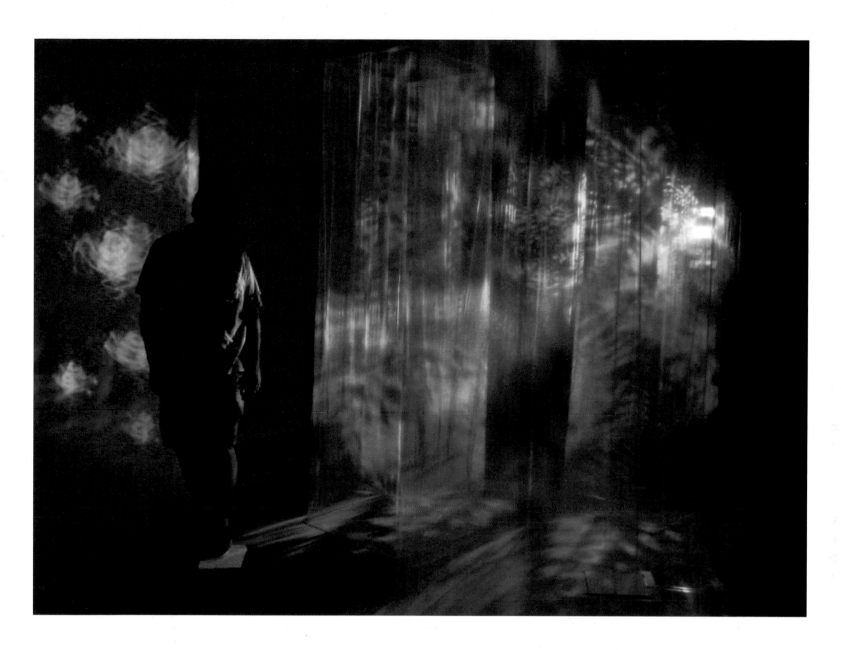

BONNIE MITCHELL, ELAINIE LILLIOS AND GREG CORNELIUS, *EXPERIENTIAL EXTREMISM,* **2003–04. INTERACTIVE AUDIOVISUAL INSTALLATION, 6 X 9 M (20 X 30 FT)**

Experiential Extremism is an immersive interactive installation that uses time-based visual and sonic events to control emotional and physical responses. The piece consists of three networked computers that control real-time, multi-layered sonic and visual events, all of which are triggered by electronic sensors. The project explores the concept of extremism in today's society.

SHERBAN EPURÉ,
***CONDOTTIERE*, 2003. INKJET
PRINT, VARIABLE DIMENSIONS**
Sherban Epuré uses the term 'meta-
phorms' to describe the results of
his mathematically based image-
generating process. This work,
produced using algorithms, is
formed by the interaction of colour
with a simple geometric shape.
One intent of Epuré's imaging is
to forge a link between Western
technology and Eastern spirituality.

What is digital art?

Fundamental to any explanation of digital art is an understanding of the
context in which we view it – the 'art experience' itself. It can be said that
great works of art communicate simultaneously on four levels: sensory,
emotional, mental and spiritual. It is this synchronicity of body, heart and
mind that helps to define our complex reactions to art, as well as to the
everyday world.

The power that electronic and digital media have on us is partly
explained by the way in which they appeal to our senses. One simple
example is our involuntary visual attraction to motion. If we enter a room
with two computers, one showing a static image and the other a moving
image, our attention will automatically turn towards the movement.
Sound, on the other hand, fills the space we are in and works on us
in different ways. While vision and hearing are the dominant physical
senses where art is concerned, other senses also have a part to play.
Touch, in particular, is an important component in experiencing many
contemporary artworks. The traditional museum and gallery etiquette
of 'Look, don't touch' cannot be applied to interactive art, which requires
the participation of the viewer and can be more accurately described as
'Look, please touch.'

The emotional and intellectual aspects of the ways we experience art are essentially a matter of how effectively an artwork can elicit a response from us. If an artwork fails to awaken any curiosity or to engage viewers on an emotional level, they are unlikely to spend any significant time with it. We may also experience a spiritual link with a work of art – a message that is communicated on an inspirational or non-intellectual, non-emotional level. Simply put, the art touches one's soul. When all of these elements combine, the art experience can become a deeply moving one.

Our experience of viewing art is further influenced by the venue. In the past, where an artwork was exhibited was often a means by which it was classified. If it was in a museum or gallery, it was considered 'art'. There is much to be said for this perspective, since curators are recognized experts in their fields and have an informed knowledge of the pieces they select for exhibition. The art historian also has a vital role, since critical writings associated with a particular artwork or artist help to create credibility.

It should be remembered that making art is far removed from the viewers' experience of it. Artists tend to be more involved with the process than with the end result, and approach the creation of an artwork as both experimental and evolutionary – something especially true of digital artists. Having chosen to use a computer to visualize a work, however, many go on to create the piece using traditional media. The forms that digital art can take – both traditional and new – can be blended in many ways, which sometimes makes the distinctions between them unclear. Traditional forms of digital art include prints, photography, sculpture, installations, video, film, animation, music and performance. New forms that are unique to the digital realm include virtual reality, software art and net art. A more complete understanding of digital art will emerge as we examine its relationship to technology and contemporary art, the way in which these artworks are created, and the inner make-up of the digital artist.

Art and technology
Digital art is intimately linked to science and technology, which are fundamental to its creation and physical substance. Arguments of technological determinism in art proclaim that it is the development of technology that has allowed artists to create these works. However, if we look at art as a creative reflection of modern culture, then digital art can be considered a subset of contemporary art. Since the adjective 'digital' is often ambiguous, and does not clearly define the work's final form, it is here applied to artworks in which artists have used the computer as a primary tool, medium and/or creative partner.

Many curators and critics see digital art as an evolutionary development of the mechanical and electrical processes of photography, film and video. This approach forms part of a larger historical perspective, in which photography itself evolved from drawing and painting. Although initially there was considerable resistance to the concept of photography as fine art, it is now widely recognized as such and occupies a place in the collections of major museums worldwide. Film is a logical evolutionary step from

photography: the physical nature of the medium is identical, although differently formatted in order to move through the camera quickly and to capture motion. Video, too, can be thought of as usurping film technology. Likewise, the internet is often considered a development of mass media, best exemplified by radio and television. One interesting aspect of mass media is its ever-increasing inclusivity: while films can contain photographs and video can contain film content and photographs, the internet is capable of communicating through text, image, sound and such time-based media as video and animation. Although an evolutionary approach to digital art based on advances in technology offers only an elementary understanding of how it relates to popular culture, it does provide a historical framework for the development of digital tools and other media now available to contemporary artists.

One dilemma that has arisen with the use of digital technology in art-making is the concept of 'the original'. Paintings are original works of art, traditional printmakers refine a work to end up with an artist proof that sets the standard for an edition of prints, and even photographers have adopted the concept of editions and originals. Since a digital file is stored electronically and can be reproduced with all its elements intact, how does it relate to the concept of the 'original'? Some artists make only a single print from their file and thus have a single original, others make limited editions of their work, and some create open editions. Needless to say, the value of an individual print in the commercial art world is dependent on how many multiples are in circulation, as well as the strength of the market for which it is intended.

A portrait of the digital artist

One way of gaining a better understanding of digital art is to consider the people who create it. Although all are involved in the familiar artistic processes of self-expression and discovery, digital artists can be characterized in several ways: some are also computer programmers who write their own code in order to create the work, whereas others collaborate with programmers and computer technicians in order to realize their creations. Even in these collaborative relationships, artists must have an understanding of both the potential and the limitations of using digital tools, as well as a fairly high level of technical knowledge. Technological curiosity is thus an important facet in the make-up of a digital artist.

Another aspect common to digital artists is a desire to create artworks using new tools and techniques. Although what is 'new' is continuously evolving, many artists were first attracted to digital tools because they offered creative opportunities not possible through traditional means. One benefit that digital tools offer is increased authorial control. This can be both a blessing and a curse, since greater control often means that creative 'accidents' happen less often. On the other hand, deliberately created random effects can provide artists with results they may not have previously considered. For example, an artist may create software that progressively changes an image over time, letting the computer create several hundred variations of an image, then selecting the final images they like best.

JAVIER ROCA, *TOPOGRAPHIC HEAD*, 2002. INKJET PRINT, 99.1 X 32.5 CM (39 X 12.8 IN)
Making full use of the unprecedented level of control that computer software offers over light, shadow and colour, Javier Roca combines traditional figurative illustration with layered elements of the techno-surreal.

**JEAN-PIERRE HÉBERT,
*UN CERCLE TROP ÉTROIT:
DÉRIVÉE SECONDE*, 1995.
INK ON PAPER DRAWING,
48 X 35 CM (18⅞ X 13¾ IN)**
Jean-Pierre Hébert is considered
one of the pioneers of digital art.
A self-defined 'algorist', Hébert
uses algorithms as the core of his
software programmes and to drive
his pen plotters. In most of his
works, he incorporates traditional
tools such as pens, pencils,
brushes, magnets and pendulums,
along with exploring alternative
media such as sound and sand.

THOMAS PORETT, *KOI SPACE/TIME*, 1999. IRIS PRINT, 89 X 56 CM (32 X 22 IN)
Although at first glance this may look like a single image, it was in fact constructed from two photographs that were merged using a 2D painting programme. Thomas Porett's work examines tensions between motion and the passage of time.

Digital artists are also risk-takers by nature, and concern for their creative work supersedes any desire to conform to the traditional art establishment. This was especially true in the early days, when digital art was looked upon as outsider art. While there were a few courageous souls experimenting with digital forms in the 1960s, 1970s and 1980s, it is only recently that museums and galleries have begun to take the art form seriously. Although this is a welcome change, it is important to acknowledge those pioneers of digital art who were willing to experiment in unfamiliar territory.

Emerging artists are now growing up with digital literacy as an integrated part of their lives. They will never know a world without the internet, laptop, mobile phones or email, to mention but a few of the technological aids that help to shape our daily existence. As such, these artists do not regard making art with digital tools as anything different from using traditional tools. The qualifier 'digital' has already begun to disappear, and these artists of the future will be considered contemporary artists.

The forms and classification of digital art

Digital art is radically new, and yet many of its facets have grown out of traditional art practice. The current tendency to categorize digital art according to established perspectives will hopefully dissipate enough to allow a deeper understanding of its techniques and purpose to be reached. As digital art continues to take a prominent place in the contemporary art world, and the language and syntax of computer technologies become more refined and familiar, we will be better equipped to define its many forms and cultural contributions.

Digital art most often takes on the form of data – that is, a computer file that exists as a collection of ones and zeros on digital storage media. Sometimes this is the final form, as with net art, in which a physical rendition of the work does not exist. Whether or not this data is transformed into something more concrete depends on the artist. As computers grow more powerful and software more sophisticated, the variety of forms (often referred to as 'polyforms' or 'meta-forms') that the data can assume is increasing. For example, a virtual object created with three-dimensional modelling and animation software can end up as a single image, as animation, or it can be output as sculpture. The animation or image can also be incorporated into a website and thus exist on the internet as net art.

The artworks presented in this book have been categorized primarily according to the final media in which they reside, as well as the intention of each artist and the author's interpretation. The forms of digital art outlined here are based on current state-of-the-art technology and include imaging; sculpture; installation and virtual reality; performance, music and sound art; animation and video; software, database and game art; and net art. In the chapters that follow, these various genres of digital art are explored in greater detail.

Digital imaging

The earliest digital art consisted of printed images drawn with line plotters or dot-matrix printers, or photographs of computer screens. The developments

in digital imaging of recent years are due mainly to the rapid growth of digital photography. The popularity of this medium has helped to quicken the development of higher image resolution, so that a continuous tone has been achieved and pixels are no longer visible. It has also facilitated the widespread use of archival pigments and papers, meaning that the life of digital prints has been greatly extended. In addition, a digital file can now be archived safely and easily for future reprints.

Prints can take many forms, from the small-format digital photograph made with archival paper on a desktop printer to specialized prints several feet in height and width. The image can also be integrated with printmaking methods, such as silkscreen; combined with traditional drawing and painting media; or incorporated into installations, sculptures or video displays.

Digital sculpture

The creation of three-dimensional objects using digital technology developed out of computer-assisted design and manufacturing (CAD/CAM). Early machines for producing sculpture digitally consisted of a subtractive process using a milling head, similar to an electric drill or router, which could be controlled in three dimensions. Intricate objects could be created, but artists were limited by the hardware: only the milling head could move, not the medium itself, and only smaller works were possible. New, larger systems are capable of milling both small sculptures and architecturally scaled works with high precision.

The process of rapid prototyping, which developed out of early CAD/CAM technology, is now quite sophisticated. Rather than having a milling head remove material from the art medium, rapid prototyping is an additive process in which extremely thin layers of wax or powder are built up to form a three-dimensional object. Some systems are also capable of

DAN COLLINS, *RETURN TO THE GARDEN*, 2003. NETWORKED VIDEO INSTALLATION WITH SCULPTURAL ELEMENTS
Over the past twenty-five years, Dan Collins has focused on overlapping three areas: digital sculpture, closed-circuit video and anamorphosis. This interactive installation utilized a networked surveillance camera that museum visitors controlled to reveal key aspects of the work. In doing so, Collins asks his audience to reconsider the dialectic between the actual and the virtual by wilfully distorting perspective through video techniques that altered the perception of digital sculptural elements hanging from the ceiling.

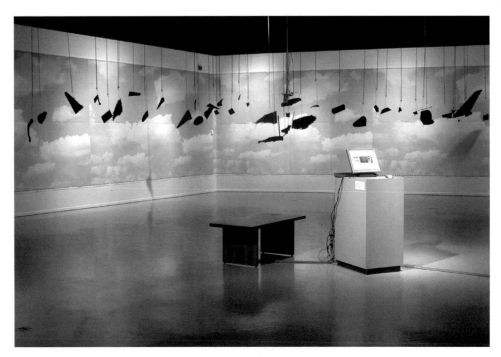

JIM CAMPBELL, *PHOTO OF MY MOTHER*, 1996; *PORTRAIT OF MY FATHER*, 1994–95. CUSTOM ELECTRONICS, GLASS, PHOTOGRAPHS, LCD MATERIAL, EACH 121.9 X 30.5 X 30.5 CM (48 X 12 X 12 IN)
Jim Campbell uses his own body tempos to control the rate at which these two images change. In the case of *Photo of My Mother*, he uses an hour-long digital recording of his breath as a timing device: as he exhales, the image changes from clear to foggy, as if breathing onto the glass, and then clears again. For *Portrait of My Father*, he uses a recording of his heartbeat to control the speed at which his father appears and disappears.

using a powder-and-inkjet process that produces objects with millions of colours. Rapid prototyping has advanced to the point that it is easily accessible and affordable. Some artists use the actual prototype as their final form, while others use them as models for a mould from which they then produce a work cast in metal or other media. Sculptors also employ digital laser technologies, which can be used on a wide variety of material. These new processes have revolutionized the way in which physical sculptures can be produced.

Virtual sculpture has emerged as a development of digital sculpture. Here, the sculptural work never assumes the form of an actual physical object but resides as a file within cyberspace or within the virtual world of the computer. Sculptors have previously always been limited by physical forces – gravity, the nature of their materials, the location and size of the sculpture, and so on. In the virtual world, the rules are entirely different. Gravity no longer applies, and size, scale and materials can be changed easily by simply choosing items on a software menu. The artist can examine the work from an infinite number of viewpoints, and he or she can create a virtual, interactive world in which to display it. Understandably, this type of creative control holds great appeal for artists.

Digital installation and virtual reality

Digital technology has greatly increased the range of creative options available to installation artists and it allows them precise control over their work. Early control systems for installation artworks had to be custom-built and were often extremely complex and expensive. Digital technologies such as hardware microcontrollers, sensors and software packages that control machine routines have emerged, allowing for art experiences that were not previously possible. Examples include interactive environments, robotics, and data-driven installations that read real-time information from the internet. This is one of the fastest growing areas of digital art, not only because of the creative control it offers, but also because participatory and interactive art is becoming an important component of contemporary art.

Virtual reality allows for the creation of an immersive experience. That is, the participant or viewer is brought into a completely synthetic world created by the artist. Virtual experiences take different forms depending on the artwork and hardware/software interface that is used: some systems require the viewer to wear a head-mounted display (HMD) or a similar type of interface device, while other virtual experiences are designed for the internet, where three-dimensional worlds can be explored through artificial characters and life-forms. As computing power increases and new interfaces become mass produced, the field of virtual reality appears ready to undergo a renaissance.

Performance, music and sound art

The effects of digital technologies on performance, music and sound art have been mainly evolutionary, but they have also enabled the creation of many new forms of expression. Performance artists have incorporated digital

TOSHIO IWAI, *PIANO – AS IMAGE MEDIA,* 1995. AUDIOVISUAL INSTALLATION
Here, a virtual score is used to trigger the keys of a piano, which in turn induce the projection of computer-generated images on a screen. The melodies, as well as the visuals they produce, are chosen by gallery visitors. Toshio Iwai's project establishes connections between notation, sound and image, and provides an almost synaesthetic experience.

technologies into their work in much the same way as installation artists. Technological advances have expanded their creative palette and given them more precise control over their performances. The influence of computers on music and sound art in particular has been nothing short of revolutionary: digital recording software has undeniably made a huge impact, but at the core of the digital music explosion lies the development of the Musical Instrument Digital Interface (MIDI).

Musical Instrument Digital Interface was developed in the mid-1980s, and its original intention was to enable synthesizers from different manufacturers to communicate with each other. MIDI achieved this through storing parameters – such as pitch, note on, note off, duration and tempo – as digital data rather than as an actual sound file. This launched a whole new world for composers. MIDI data can be manipulated like text in a word processor so that harmony parts can be easily added or removed, different instrumental sounds can be heard and changed quickly, sheet music can be generated automatically from a performance (rather than being handwritten), and composers are no longer confined by the physical limitations of a particular instrument. When combined with digital audio recording software, MIDI offers composers and musicians the capabilities of the most sophisticated recording studio on their personal computers; and when converted into a format compatible with MP3 players or the Apple iPod, their work can be distributed via the internet to an international audience.

Digital animation and video
The transition from traditional animation, film and video to their digital counterparts has had profound repercussions both for artists and for the commercial film and broadcast industries. Traditional animation was created entirely by hand; early animators produced literally thousands of

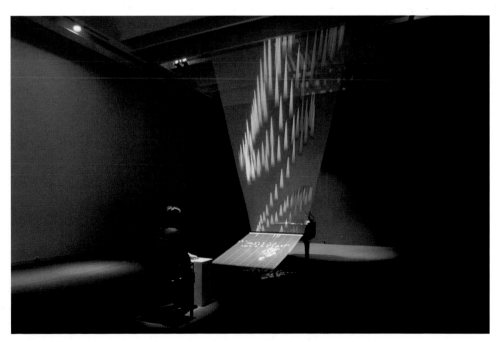

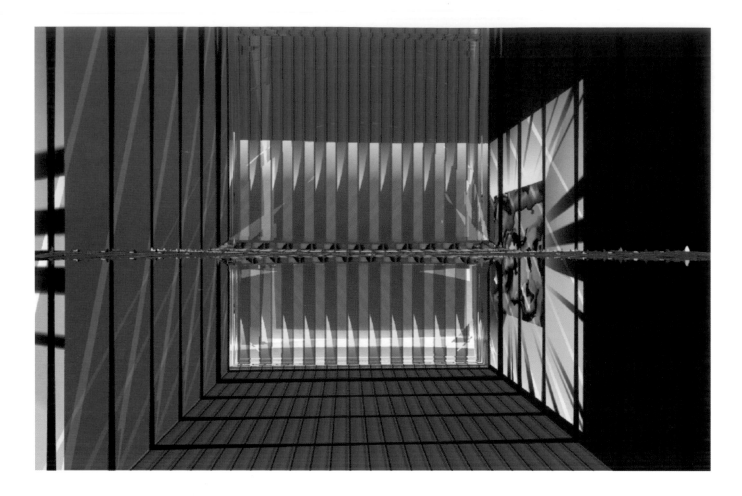

DENNIS H. MILLER, *PAST TENSE 1*, 2001. DIGITAL ANIMATION FRAME
This still frame from *Past Tense* reveals Dennis H. Miller's technique of exploring a defined colour space through background and foreground elements. Dense, morphing textures appear throughout the work and several small referential objects are used to create continuity. Miller's approach to abstract animation also includes the use of highly coloured images that often demonstrate repeating patterns, similar to the use of rhythmic structures in music.

drawings as part of a long and expensive process, which by necessity became a collaborative endeavour. One early influence of computers on animation was the advent of digitally controlled animation cameras, which automated most of the time-consuming camera work. Today, animation makes use of digital production systems whereby drawings are scanned, coloured and composited within the computer before being output to film, video or a digital format such as DVD.

Three-dimensional computer animation is unique to the digital realm and has a completely different look from that of hand-drawn animation. It has been widely adopted by the film and game industries, and a new genre of three-dimensional computer-animated feature films has emerged. In addition, versions of the software used to make these films can now be run on a personal computer, creating new interest among artists working in short-form animation. Dozens of international festivals and a myriad of websites currently offer venues for this type of work.

The production of video has also changed substantially, since artists now have the ability to produce high-quality videos on their personal computers. Technological advances in this area, coupled with the relative affordability of high-quality digital video cameras, have fostered tremendous growth in the independent video movement and have brought video and DVD production into mainstream culture.

BENJAMIN FRY, *VALENCE*, 1999. VISUALIZATION SOFTWARE.

Valence is data-visualization software designed to show structures and relationships between large sets of information. It can be used to analyse anything from literary texts to a series of genomes. Words and discrete pieces of information that are used frequently tend to appear around the screen's outer edges.

Software, database and game art

While most digital media have their roots in traditional art forms, software, database and game art are based solely on the digital. Software and game art can be defined as works of executable code written by an artist, either alone or in collaboration with a computer programmer. The running, or execution, of the programme is what creates the artwork. Examples of software and game art include interactive drawing and music software, algorithmic and generative works, data transformation, net art, artistic games and many others.

Database art is a variation of software art that depends on existing data to form the work's substance. While software art relies on the instructions carried out by a programme, database art concentrates on interpreting an existing body of data for which artists either appropriate databases or create their own. Again, this division is arbitrary and many hybrid forms exist. There are those who feel that this type of digital art is one of the few 'pure' forms of digital art, since it has not evolved directly from traditional media.

Net art

Although artists have been using the internet since its inception, it was during the mid-1990s, when graphical browsers such as Netscape and Internet Explorer were invented, that net art gained prominence. Net art uses the internet as its final medium. It can be thought of as a networked variation of software art, but is separated into its own category because of the large number of artists involved in this type of work. Artists are attracted to the freedom of the internet, the ability to create independent websites without censorship or external controls. This allows them to bypass the traditional gallery and museum establishment and to reach an immediate and international audience. When net art first appeared, it also represented fresh creative territory, with few historical precedents. It has continued to

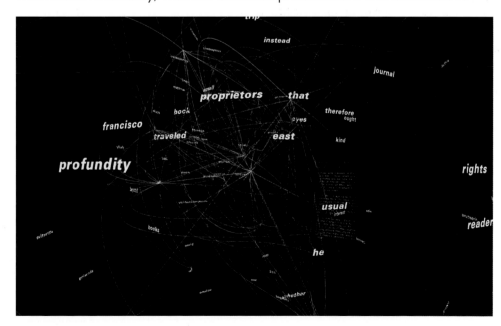

evolve, but has also been a victim of rapid changes in software and hardware: the lifespan of internet hardware and software during the latter part of the 1990s was approximately six months, and upgrades to browser software caused some early work to become obsolete. In spite of these difficulties, the freedom and control artists enjoy in the field of net art have kept it a vibrant art form.

A history of digital art

The roots of digital art are ancient and varied. Indeed, it could be argued that the prehistoric cave-paintings found in France and northern Spain provide not only some of the earliest examples of graphic storytelling, but also the earliest examples of immersive environments. As evidenced by sites such as Stonehenge, by the art and monuments of the Classical antiquity and by the calendar systems of the Mayans, peoples around the world, from the earliest times, considered the disciplines of science, astronomy and mathematics fundamental to their art and culture.

It was during the 19th century, a period in which scientific advances and inventions abounded, that the infrastructure underlying the computer revolution was truly established. In 1834, Charles Babbage conceived of the Analytical Engine, a hand-cranked, mechanical machine for automating calculations that anticipated virtually every aspect of present-day computers. Other events relevant to the history of computing were the invention of the telegraph and Morse code (a primitive precursor of binary code), the design of the first keyboard (initially for the typewriter), and the invention of the telephone by Alexander Graham Bell in 1876. In addition, George Eastman released the Kodak camera and roll film in 1888, which in turn led to the invention of stop-motion animation by George Méliès in 1895. These advances ushered in the era of mechanical and electronic media.

Opposite

BRUCE WANDS, *HEARTLINE*, 1976. PLOTTER DRAWING ON PAPER, 30.5 X 30.5 CM (12 X 12 IN)
This early example of digital image-making was created using the ArtSpeak programming language and printed on a line plotter connected to the IBM 360 mainframe computer at Syracuse University, New York.

Right

KIT GALLOWAY AND SHERRIE RABINOWITZ, *HOLE-IN-SPACE*, 1980. VIEW OF THE BROADWAY DEPARTMENT STORE WINDOW, CENTURY CITY, LOS ANGELES
This pioneering work in telecommunication art used live satellite transmission and high-quality live video and audio to connect unsuspecting members of the public in New York and Los Angeles. Initially described as a 'public communication sculpture', this work became a benchmark and helped set the stage for the development of net art.

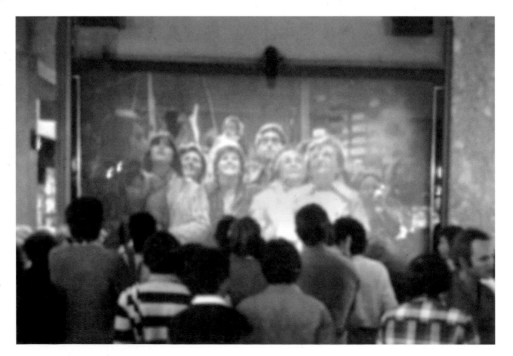

LEON HARMON AND KEN KNOWLTON, *STUDY IN PERCEPTION*, 1966. COMPUTER-GENERATED PRINT, 1.52 X 3.66 M (5 X 12 FT)
One of the most well-known examples of early digital art, this image of a reclining nude was created from 8 frames of 35 mm microfilm using a Stromberg-Carlson 4020 microfilm printer (which produced characters by means of its 'Charactron' tube and vectors). The frames were then printed, abutted, rephotographed and enlarged.

True digital art came into existence shortly after the development of the computer. Following the end of the Second World War, new systems that had been devised for weaponry were adapted for other uses. One result was the invention of the Electronic Numerical Integrator and Computer (ENIAC), based at the University of Pennsylvania, in 1946, which represented the dawn of the digital age. From this point onwards, people began to exploit for aesthetic ends the ability of computers to carry out advanced mathematical calculations.

One of the first to incorporate technology into his artistic practice was Ben Laposky. In the early 1950s he produced electronic images of wave forms on the oscilloscope (a device that uses a cathode ray tube to produce a visual record of an electrical current on a fluorescent screen), which he then photographed. These were complex, mathematically based patterns that could not be drawn by the human hand. Technology was also influencing the world of music and installation: in 1958, Edgard Varèse created his *Poème Electronique* at the World's Fair in Belgium, a sound installation consisting of hundreds of speakers placed in a unique sculptural space designed by the architect Le Corbusier. The work was a foretaste of sound art, and its sound-world consisted of a collage of studio recordings, altered piano sounds, bells and modified recordings of choral music. Both of these examples give an idea of how art and technology were beginning to merge. Much of early experimentation in the aesthetic application of computers was conducted at universities and at the research centres of large companies, such as Bell Laboratories in New Jersey.

The 1960s marked a period of great progress in the development of computer technology – mostly a spin-off of the NASA space programme, which had begun in 1958. The decade also saw increased interest among artists in computer-generated art. In 1966, Leon Harmon and Ken Knowlton created *Study in Perception*, portraying a reclining nude (pp. 22–23). During the 1960s, the American Standard Code for Information Interchange (ASCII) character set was developed to standardize the way in which text data was stored and handled. It consisted of binary code that represented letters, numbers, punctuation marks, symbols and other keyboard functions. ASCII art developed from this code and is still being created today.

Other technological milestones of the late 1960s included the invention of the mouse by Douglas Engelbart in 1968; the frame buffer, which allowed computers to store images for the first time, developed by Bell Labs; and the establishment in 1969 of ARPANET, a localized prototype of the internet – by the United States Department of Defense.

The 1960s also saw a number of seminal exhibitions of computer art at galleries such as the Studiengalerie der TH and Galerie Wendelin Niedlich in Stuttgart, Germany, and the Howard Wise Gallery in New York. In 1966, Billy Klüver established Experiments in Art and Technology (EAT) to encourage interaction between artists and engineers – a group that included Andy Warhol, Robert Rauschenberg, Robert Whitman and John Cage, among others. Two years later, 'Cybernetic Serendipity' debuted at the Institute of Contemporary Arts (ICA) in London and the British Computer Arts Society was founded.

MANFRED MOHR, *P-701B*, 2000. ENDURACHROME INKJET PRINT, CANVAS, WOOD. 141 X 114 CM (55½ X 44⅞ IN)

Considered to be a pioneer of digital art, Manfred Mohr began his career as an action painter and jazz musician. Not satisfied with spontaneous creativity, he turned to more systematic and geometric forms of expression.

The development of digital art during the 1970s was characterized by artists' continuing exploration of technology. Access to computers was still difficult, and the majority of creative experimentation remained based at research centres, but many building blocks of digital art were nevertheless produced during this period. In 1970, Xerox Corporation established the Palo Alto Research Centre (PARC) at Stanford University in California, with a directive to research computer graphics applications. Also in 1970, General Electric Company introduced Genigraphics, the first high-resolution colour graphics system. Although primarily designed for business graphics applications, it was also used by artists to create high-quality digital images.

While working as a researcher for IBM in 1975, Benoit Mandelbrot developed the concept of fractal geometry, which allowed natural forms to be described through mathematics. The Apple II computer in 1977 brought artists the first personal computer with colour graphics capabilities, and

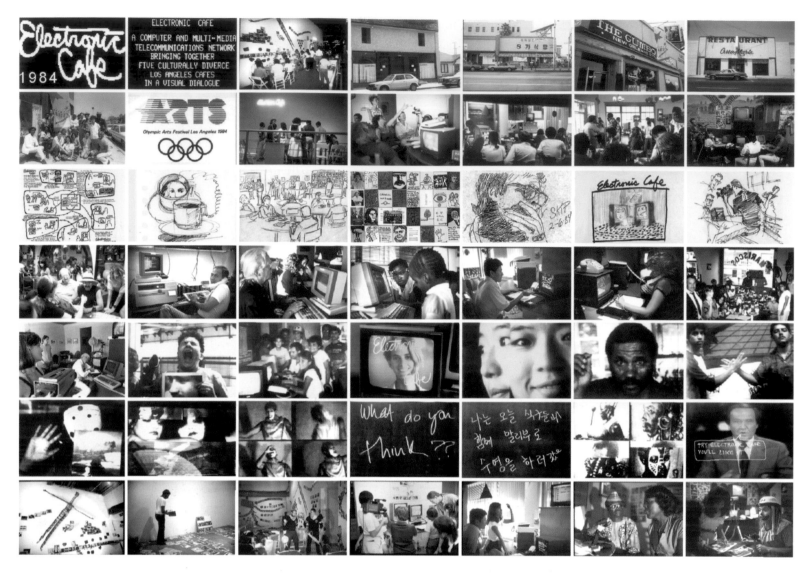

the development of the modem (shorthand for modulator/demodulator) in 1979 enabled the transmission of digital signals over phone lines.

Many prominent professional organizations whose support of the digital arts has been highly influential were founded during this decade. As part of the Association for Computing Machinery (ACM), the Special Interest Group for Graphics (SIGGRAPH) was formed in 1973 and has been at the forefront of developments in computer graphics since its inception. Ars Electronica was established in Linz, Austria, in 1979 to support the development and exhibition of electronic arts, and holds an annual festival that provides a showcase for this work. Thus the 1970s witnessed not only valuable technological advancements for digital artists, but also the beginnings of formal institutional support for digital art.

The following decade was characterized by very rapid advances in the creative uses of computers. Personal computers came into the marketplace and access to digital systems became significantly easier and more affordable. Institutions that supported this development also continued to emerge. The MIT Media Laboratory, founded by Nicholas Negroponte in

KIT GALLOWAY AND SHERRIE RABINOWITZ, *ELECTRONIC CAFE*, 1984. TRANSCULTURAL MULTI-MEDIA TELE-COLLABORATIVE NETWORK

Kit Galloway and Sherrie Rabinowitz's *Electronic Cafe* project was commissioned by the Los Angeles Museum of Contemporary Art to link culturally diverse local communities during the 1984 Summer Olympics Arts Festival. It ran for seven weeks and quickly evolved into the Electronic Cafe International (ECI), the prototype for future public cyber-venues. Operated as a networked cultural research lab, it comprised of more than forty affiliates around the globe. ECI functioned as a multi-cultural community that conducted aesthetic research in the exploration of real-time networked collaborative multi-media environments.

1980, involved artists from the time of its conception. The following year, IBM released its first personal computer, which offered artists a machine capable of a limited palette of colours and resolution. With software programmes such as Paintbrush now available, artists could create digital images and output them to slides or paper prints. Adobe Systems was founded in 1982 and remains a leader in digital-imaging software, and the compact disk (CD) was introduced in 1983. Such developments were warmly embraced by those who were creating artwork with digital media. Although the opportunities for exhibiting were still quite limited, artists were increasingly investigating the new creative frontiers offered by these expanding technologies.

During this period, artists also began to focus on telecommunications and animation. One early telecommunications art event was the *Hole-In-Space* project by Kit Galloway and Sherrie Rabinowitz (p. 20), which used a satellite link to enable people in New York City and Los Angeles to interact with each other through life-size video screens. Four years later, Galloway and Rabinowitz co-founded the *Electronic Cafe* (p. 26), another global project designed to link different cultures through telecommunications. Although there was no World Wide Web at that time, a wide variety of other technologies were being employed. *The World in 24 Hours*, organized by Robert Adrian in 1982 and based in Linz, Austria, included groups of artists in fifteen cities around the world who held a series of dialogues through telephone, fax and computer systems.

Computer animation also developed quickly during the 1980s. In Tokyo, *Growth*, the first in a series of computer animations, was created by Yoichiro Kawaguchi in 1983. Three years later Pixar was founded by Steve Jobs of Apple Computers when he purchased the Lucasfilm Computer Graphics Division from George Lucas. Early research at Pixar was extremely important in the development of three-dimensional computer graphics imaging and animation. As animation software became more user-friendly, artists began to experiment more, primarily because it opened up possibilities that had not existed with traditional methods.

Two other major technical innovations came about in 1984: the debut of the Macintosh computer, as mentioned, and the establishment of the Musical Instrument Digital Interface (MIDI). The early Macintosh computers, although offering only black-and-white printing options, ushered in the era of 'desktop publishing'. While the black-and-white pixelated images initially produced were somewhat primitive in comparison with those made by traditional printing methods, artists saw the potential of this new technology. Within the field of music and composition, the advent of MIDI technology revolutionized the music recording industry by making it possible for musicians to own a studio-quality recording system at a reasonable cost.

By 1985, AT&T had developed the TARGA 16 graphics card, which allowed for 16-bit images and 32,000 possible colours. This was a significant development for artists. Although the new card was a considerable improvement, it was not until 24-bit colour was introduced a few years later that computers were able to achieve true photographic

CHAR DAVIES, *TREE POND, OSMOSE*, 1995. DIGITAL STILL IMAGE CAPTURED DURING IMMERSIVE PERFORMANCE OF THE VIRTUAL ENVIRONMENT *OSMOSE*.

Osmose was produced using advanced technology such as stereoscopic 3D computer graphics, spatialized 3D sound and real-time interaction. Participants wear a head-mounted display and a motion-tracking vest that records their breath and balance, enabling them to experience its virtual space. Composed of ever-changing, semi-transparent elements, *Osmose* contains a dozen spatial realms, including a forest, clearing, pond and under-earth, as well as a substratum of software code and upper area of philosophical texts referring to nature, embodiment and technology. *Osmose* was the first virtual environment to employ breath as a means of interface, and to use transparency in real-time. Originally designed to run on a large computer, in 2002 *Osmose* and its successor *Ephémère* were rewritten to run on a PC.

colour resolution and reproduction. To take advantage of this, Adobe developed Photoshop software, which has become an industry standard for image creation and manipulation. These developments in technology, animation and image-making capabilities attracted an even greater number of artists to experiment and create with personal computers.

In 1987, Bernhard Leitner introduced *Head Spaces*, a series of audio sculptures featuring manipulated electronic sounds that were listened to with stereo headphones. In the same year Lillian Schwartz created *Mona/Leo*, which proposed the idea that Leonardo had based the *Mona Lisa* on his own self-portrait. In 1989, Jeffrey Shaw launched *The Legible City*, an interactive environment in which viewers would use a stationary bicycle to navigate around a virtual city, whose 'buildings' were made up of three-dimensional typography. This was one of the first works of art to explore movement through a three-dimensional space that existed solely within the computer.

Educational institutions began to teach computer art on a formal level during this period, and the 1980s ended with the establishment of the first Master of Fine Arts in Computer Art degree programme in the United States at the School of Visual Arts in New York. Books on digital art began to appear. In 1987 *Digital Visions: Computers and Art* by Cynthia Goodman was published in conjunction with an exhibition of digital art at the Everson Museum in Syracuse, New York.

Interest in the digital arts continued to increase throughout the following decade. Computers were now making considerable inroads into creative professions, particularly the field of graphic design. The rapid growth of the internet in the mid-1990s dramatically changed the way in which people communicated and conducted business. The dot.com era not only fuelled the economy, but also introduced new ways in which cultures could interact. A global sensibility was evolving among artists, and the internet was regarded as new creative territory, allowing them to reach international audiences. HyperText Markup Language (HTML) was developed in 1992, paving the way for the World Wide Web. Mosaic, the first example of a graphical web browser, which allowed one to see a combination of text and images while navigating the internet, was released a year later, and the Netscape browser quickly followed. Jodi, the artistic team of Joan Heemskerk and Dirk Paesmans, were among the first artists to experiment with net art. Exhibitions and venues for digital art were also on the rise and, in 1993, the first New York Digital Salon was held at the New York Art Directors Club. Benjamin Weil, Vivian Selbo and Andrea Scott launched äda'web in 1995, an online 'foundry' for artists to experiment with, and reflect upon, the web as a medium.

Interactive art using digital technologies became more prevalent during this period as well. *Sonata*, an interactive cinema work, was created by Grahame Weinbren and Roberta Friedman in 1991 and explored new ways of perceiving cinema. In 1994, Christa Sommerer and Laurent Mignonneau created *A-Volve*, an interactive real-time environment, while Char Davies explored similar virtual reality environments with *Osmose* in 1995 (see above) and *Ephémère* in 1998 (pp. 104–05). This was a very

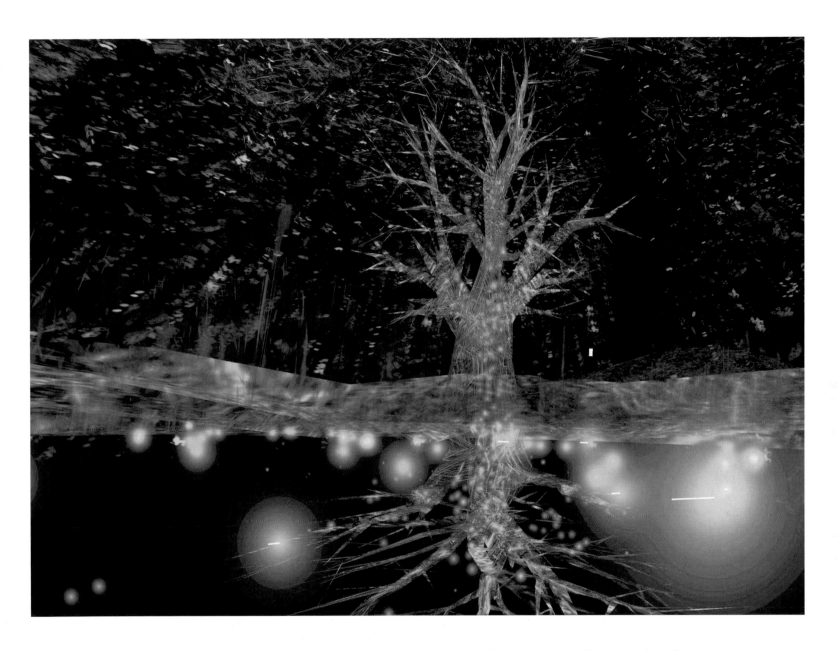

fertile time for digital art, as new creative frontiers were discovered and technology continued to develop at an astonishing rate.

In 1996, John F. Simon, Jr. unveiled *Every Icon* (p. 171), which creates random images based on a 32 x 32 pixel grid – the standard size for computer icons. The unique mathematical nature of this work brought considerable critical attention to net art from the larger art community. Simon also challenged the notion of the conventional art marketplace by selling the work on amazon.com. This piece, and other software and net artworks by artists such as Eduardo Kac (pp. 114–15), Rafael Lozano-Hemmer (pp. 204–05) and John Klima (pp. 31, 132), revolutionized digital art and helped establish its reputation among galleries, museums and curators as a serious art form.

Fuelled in part by the continued rapid development of technology, at the beginning of the 21st century the general public and the international

business community were celebrating the rise of the dot.com economy and an international digital cultural boom. The year 2001 brought attention to digital art through several major museum exhibitions in the United States, such as the San Francisco Museum of Modern Art's '010101: Art in Technological Times'. Including both digital and traditional artworks, the show was conceived as an investigation into the effects of technology on our lives. The 'BitStreams' and 'Data Dynamics' exhibitions, both held at the Whitney Museum of American Art in New York, were significant American museum shows of digital art.

New forms of digital art continued to be invented and to push the boundaries of creative expression. Alexander R. Galloway and the Radical Software Group launched Carnivore software, which is based on a surveillance tool used by the FBI to monitor data networks. Innovative forms of performance art also emerged, including *Symphony #2 for Dot-Matrix Printers* written by [The User]. By creating an 'orchestra' of various printers, these artists had a broad palette of sounds with which to compose. Large-scale light installations included Erwin Redl's *Matrix IV* (p. 119), which was exhibited as part of the 2001 Whitney Biennial. Database art was also gaining recognition with *Pockets Full of Memories* by George Legrady (pp. 175–77). This work scanned the pocket contents of gallery visitors and then attempted to identify the objects.

Today, digital art continues to flourish in museums and galleries. It is slowly becoming incorporated into the contemporary art landscape, as many of the perceived differences between digital art and contemporary art become blurred. We are in a period of transition: artists of the future will never have known a world without computers, and are unlikely to distinguish between art created with technology and other types of contemporary art.

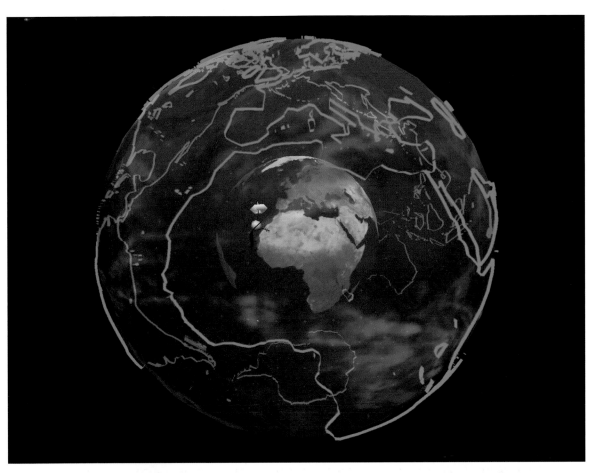

JOHN KLIMA, *EARTH*, 2002. NETWORKED SOFTWARE

Earth is a software system that takes data from the internet and visualizes it over a 3D model of the Earth, so that users can zoom in and examine various data layers, such as Landsat 7 satellite images, weather imagery and satellite-mapped topography. The final layer allows users to 'fly' through localized terrain, created by the artist from the upper topographical layer.

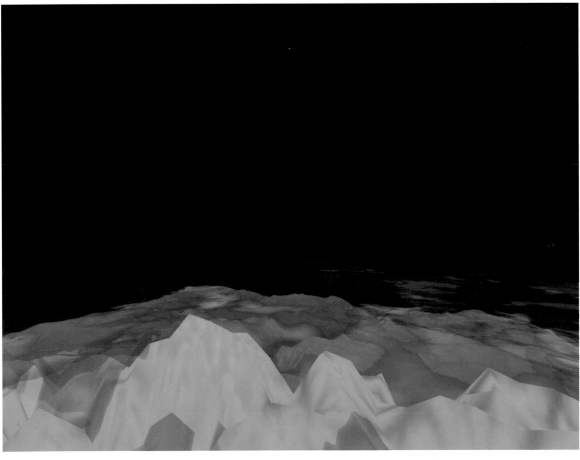

This ability to reproduce works at the click of a button has given rise to the question of how we should approach the concept of original prints and editions, so fundamental to printmaking. Some artists choose to print only a single original of a work; many issue limited editions; and others produce open editions. Some artists even provide a copy of the digital file in case an original print should become damaged or faded. All of these practices affect the pricing and availability of digital prints, and to date no standard has evolved.

The digital image maker's studio

Depending on their background and artistic concerns, many digital artists still use traditional image-making tools: pencils, brushes, paints, assorted papers, photographic equipment and so on. They will also have digital work areas, housing the technological components: computer, monitor, scanner, printer, graphics tablet and related peripherals. Computers that specialize in image-making generally have a big monitor, a large amount of random-access memory (RAM) and storage capacity on the hard drive, and a high-performance graphics card. With these features, the artist can choose to create images through photographic manipulation, compositing or freehand drawing with pixel-based software; by plotting points, lines and curves using vector-based software; or by using algorithmic methods or three-dimensional modelling software.

Artists who create two-dimensional images have studios equipped with software packages such as Adobe Photoshop. As the name implies, this software was originally created for working with photographs. Artists can also draw with this application, and it is a primary tool for commercial illustration. Photoshop offers the choice of producing either pixel-based images or vector designs. Files made up of pixels have a specific resolution, and each pixel or dot is assigned a colour. Resolution can be defined as the number of horizontal and vertical pixels contained in an image, e.g. 1024 x 768. Resolution determines the quality of the image; for example, high-resolution files used for printing usually have 300 dpi (300 pixels or 'dots' per inch). Vector images, on the other hand, are defined mathematically. Specific vector-based software packages such as Adobe Illustrator have an advantage over bitmapped (pixel-based) software packages in that they are resolution independent. These programmes use mathematically defined points, curves and shapes to create the image, instead of defining it through a finite number of pixels. The work can be scaled to almost any size without losing quality of line. These imaging methods are by no means exclusive and can be combined in a variety of ways.

Yet another group of digital artists equip their studios with three-dimensional modelling and animation software such as Alias Maya. These programmes offer a tremendous range of options. Unlike two-dimensional systems that work like painting on canvas, where all the elements of light, shadow and perspective are produced through the manipulation of colours, three-dimensional systems create a database that defines all the parameters of the image or object in mathematical space. The artist is able to place

cameras, lights and objects into that space, from which the computer renders an image. Charles A. Csuri (pp. 36–37), Kenneth A. Huff (pp. 2, 39), Juan Antonio Lleó (pp. 60, 130–31) and Robert Michael Smith (pp. 68, 97) are among the artists who use this method to create their work. In addition, the final form these files take can be defined by the artist as an image, an animation or even a three-dimensional sculpture, since the data can be saved in a variety of file formats.

Although the works included here represent only a small number of the artists working in digital image-making today, they reflect a variety of styles, from the representational to the abstract, and illustrate diverse approaches and solutions to the integration of computer technologies into existing artistic practice. Ultimately, it will be the task of art historians to help define the impact of digital image-making and its aesthetic concerns on the field of traditional printmaking.

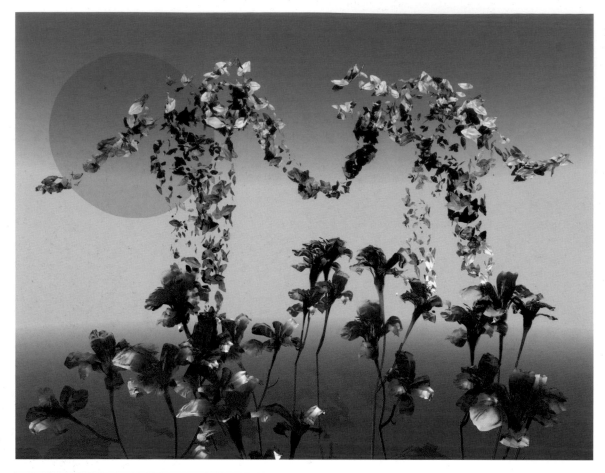

Left
CHARLES A. CSURI, *GARDEN LOVERS*, 1997. INKJET PRINT, 76.2 X 101.6 CM (30 X 40 IN)
A pioneer of computer imaging and animation, Charles A. Csuri creates 3D images that take a variety of final forms. These fragmented figures, constructed entirely of leaves, appear to be dancing in an otherworldly garden.

Below left
CHARLES A. CSURI, *POLITICAL AGENDA*, 1999. CIBACHROME PRINT, 121.9 X 165.1 CM (48 X 65 IN)
Here, a ray-tracing algorithm is used to represent the properties of glass, which appears to distort the objects in the background.

Opposite
CHARLES A. CSURI, *HORSE PLAY*, 1996. INKJET PRINT, 76.2 X 101.6 CM (30 X 40 IN)
These horses are composed of ribbon-like threads that reflect light and cast shadows.

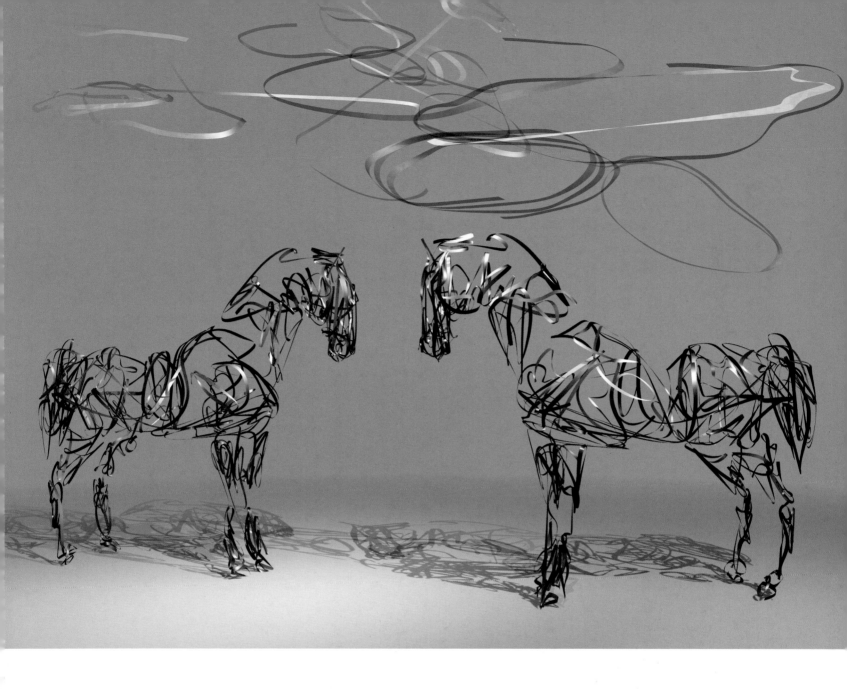

FROM 1965, COMPUTERS REVEALED TO ME A CONCEPT OF CREATIVITY THAT INVOLVES A HIERARCHICAL PROCESS OF CONTROL. I WORK AT THE TOP LEVEL USING COMPLEX ALGORITHMS TO DEFINE RULES OR CONDITIONS FOR THE REALIZATION OF AN IDEA. FOR ME THERE IS NO SINGLE SOLUTION: EACH INSTANCE OR FRAME IS DIFFERENT. THE IDEAS BECOME ANIMATIONS OR SLIDE SHOWS THAT COULD RUN UNTIL THE END OF TIME.
CHARLES A. CSURI

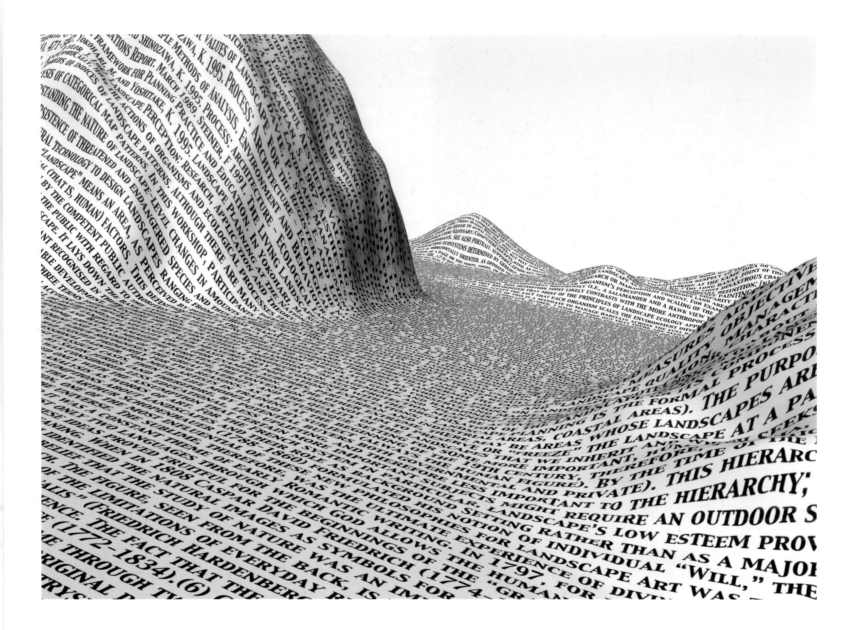

Above
**ROBERT BOWEN, *LITERARY LANDSCAPE*,
2004. DRY ARCHIVAL PRINT,
76.2 X 101.6 CM (30 X 40 IN)**
This piece sits on the border between image-making
and net art, engaging the viewer on visual and
intellectual levels simultaneously. It is part of a series
of images based on the artist's relationship with novels,
personal writings, online texts and translations.

Opposite
**ROBERT BOWEN, *FINNEGAN'S WAKE*
(JAMES JOYCE), 2004. DRY ARCHIVAL PRINT,
76.2 X 101.6 CM (30 X 40 IN)**
Robert Bowen has used text from James Joyce's novel
Finnegan's Wake to form the substance of this image.
While somewhat abstract from a distance, close
examination reveals an incredibly dense collection
of words.

HERE I EXPLORE MY RELATIONSHIP WITH A VARIETY OF TEXTS. ALL THE IMAGES HAVE ONE THING IN COMMON: THEY ARE CREATED WITH TYPOGRAPHICAL SYMBOLS AND THEY FUNCTION BOTH AS PICTURES AND AS TEXTS. ULTIMATELY, FOR ME THEY ARE VIRTUAL IMAGES OF VIRTUAL THINGS.
ROBERT BOWEN

DIGITAL ART HAS GREATLY AFFECTED HOW I CREATE AND THINK ABOUT MY WORK. I SEE MY WORLD IN PIECES. I CONCEIVE OF IDEAS THAT I WILL EVENTUALLY VISUALIZE USING THESE PIECES. IT IS THIS CREATIVE PROCESS THAT AFFORDS ME A METHOD OF WORKING.
DENA ELIZABETH EBER

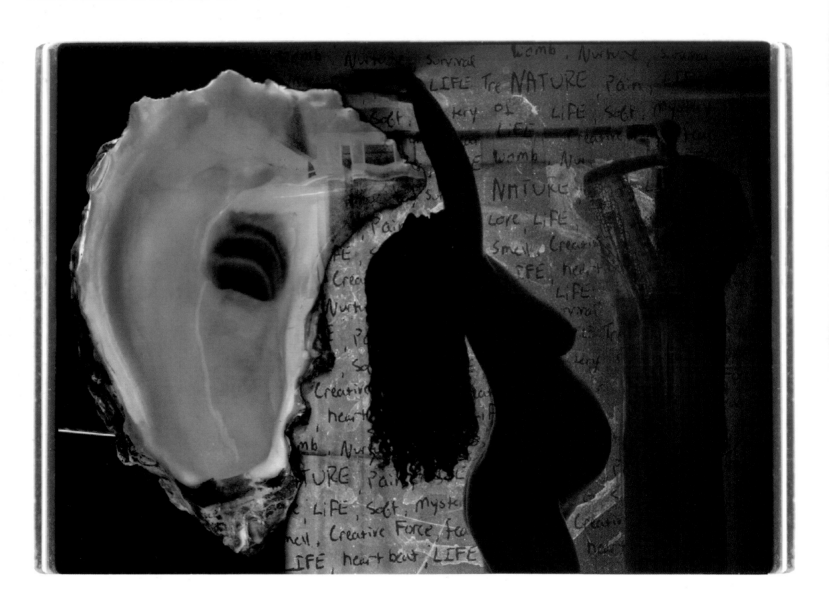

Above
DENA ELIZABETH EBER, *CONVERSATIONS 1*, 2000.
DIGITAL IMAGE, 54.6 X 76.2 CM (21½ X 30 IN)
Conversations is a series that explores family lineage and relationships by means of visual juxtapositions. In this image, the artist illustrates the first conversations she had with her unborn daughter. The series is part of a larger body of work, *Aitz Chayim*, which means 'The Tree of Life' in Hebrew and symbolizes growth, motherhood, strength, life, immortality and rebirth.

Opposite
ROBIN DOHERTY, *UNTITLED 1*, 2001.
DIGITAL PRINT, 76.2 X 76.2 CM (30 X 30 IN)
While the media Robin Doherty works in range from photography to sculpture and installation, his main concern is with the search for self-knowledge. Some of the adjectives he uses to describe his work are 'metaphysical', 'meditative', 'intuitive' and 'iconic'. His concern with the iconic is evident in the focused gaze of this child's face.

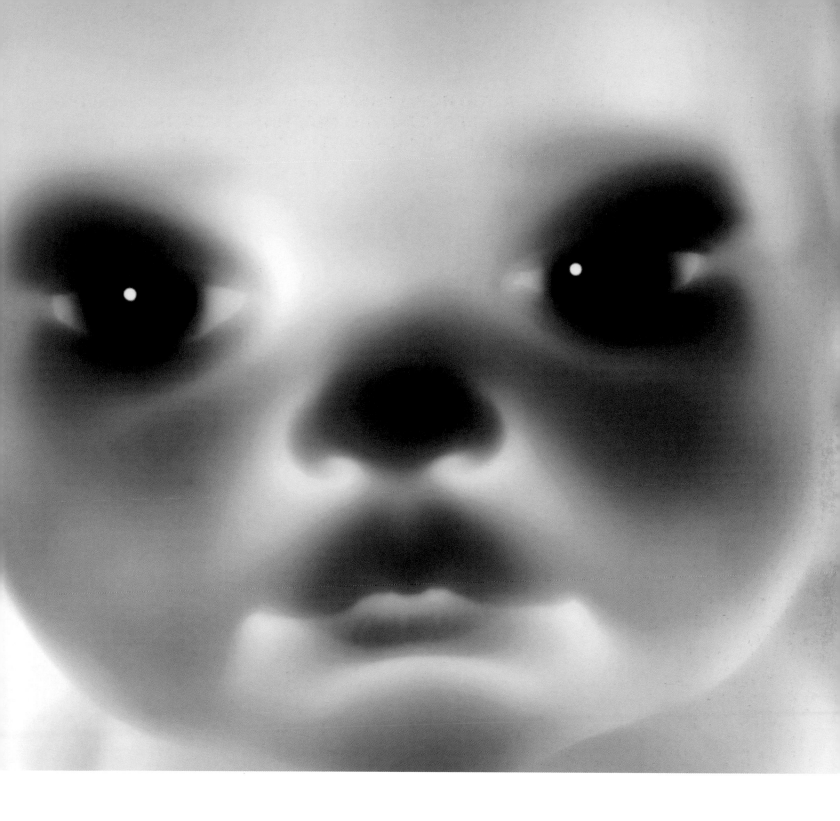

THE MOST IMPORTANT EFFECT THAT THE DIGITAL PROCESS HAS HAD FOR ME IN RESPECT OF MY ART PRACTICE IS THAT IT HAS GIVEN ME THE FREEDOM TO PLAY BEYOND SET BOUNDARIES. THE USE OF THE WORD 'PLAY' BY NO MEANS SUGGESTS A NON-SERIOUS OR TRIVIAL INFERENCE: PLAY IS FUNDAMENTAL TO ALL ART AND IN THE DIGITAL PROCESS WE HAVE FOUND AN IMPORTANT AND EXCITING FORM OF THIS, GIVING NEW POSSIBILITIES OF SUCH A FLUID AND DYNAMIC NATURE THAT ITS IMPORTANCE CANNOT BE OVERSTATED.
ROBIN DOHERTY

WHEN I FIRST BEGAN TO USE COMPUTERS, IDEAS CAME UP THAT WOULD NOT HAVE OCCURRED TO ME OTHERWISE, AND THE IMAGES BEGAN GROWING INTO AND OUT OF EACH OTHER. EVENTUALLY I WAS ABLE TO USE THE COMPUTER INTUITIVELY, AND AS THE TOOL BECAME MORE TRANSPARENT TO ME, I BEGAN TO EXPLORE THE UNIQUE QUALITIES OF THE COMPUTER AS AN ART MEDIUM.
DAVID EM

Opposite
DAVID EM, *GUADALUPE*, 1998. COMPUTER GRAPHICS IMAGE, VARIABLE DIMENSIONS

Left
DAVID EM, *GLACIER*, 1997. COMPUTER GRAPHICS IMAGE, VARIABLE DIMENSIONS
David Em is a pioneer of digital imaging, having first worked with computers in 1975 with the Superpaint programme at the Xerox PARC research facility.

MANY OF MY PIECES HAVE REFERENCES, ECHOES, TO THE THEATRE AND OTHER LITERARY, ARTISTIC AND SCIENTIFIC IDEAS AND PHILOSOPHIES. SPECIFICALLY, I AM FASCINATED BY THE WORK OF THE SURREALISTS – RENÉ MAGRITTE AND SALVADOR DALÍ – THE IDEA OF *TROMPE L'OEIL* PAINTING, OF TIME, SPACE AND RELATIVITY, CHAOS THEORY AND, OF COURSE, THE CLASSICAL THEATRE OF THE GREEKS. WHERE THIS WILL TAKE ME I AM NOT SURE – BUT I LOOK FORWARD TO THE JOURNEY.
JOHN CAMPBELL FINNEGAN

JOHN CAMPBELL FINNEGAN, *TEMPORAL DISTORTION*, 2002. GICLÉE PRINT, 91.4 X 182.9 CM (36 X 72 IN)
John Campbell Finnegan creates images that are abstract and fluid. His work combines photography, painting, collage and scanned 3D objects.

MY WORK DERIVES TECHNICALLY FROM TWO DIFFERENT MEDIUMS: FROM THE COMPUTER, WHICH I FIRST LEARNED AS A GRAPHIC DESIGN TOOL, AND FROM PHOTOGRAPHY, WHICH OPENED A SURPRISING NEW REALM OF MEANING FOR MY WORK. I WAS ABLE TO FIND MY OWN VOICE AND TO CREATE PERSONAL LANDSCAPES FROM IMAGES THAT COMPELLED ME TO PHOTOGRAPH THEM.
DIANE FENSTER

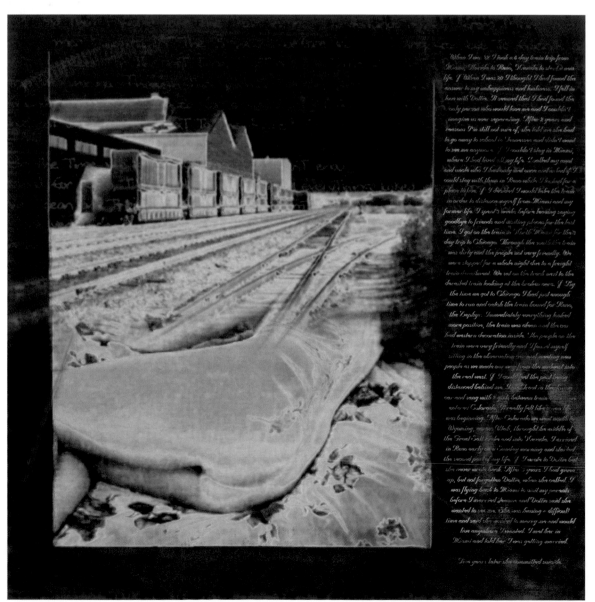

Left
DIANE FENSTER, *I COULDN'T STAY IN MIAMI*, 1994. FUJICHROME SUPERGLOSS PRINT, 76.2 X 76.2 CM (30 X 30 IN)
This image is from the series *Ritual of Abandonment*, which explores the emotions of love, abandonment and relationships through the intermingling of images and text. A term Diana Fenster uses to describe her work is 'psychological narrative'. In 2001 she became the first artist to be inducted into the Photoshop Hall of Fame. Fenster's work is a combination of still video, photography, video and scanned imagery. She also creates installations that incorporate her imagery (p. 106).

Opposite
TAMÁS F. FARKAS, *CELTIX-4*, 2003. DIGITAL GRAPHIC, 42 X 29.7 CM (16½ X 11⅝ IN)
Tamás F. Farkas uses the computer as a design tool. Influenced by multi-dimensional geometry and abstract symmetries, as well as the works of M. C. Escher, his works are dissymetric in their construction, with the intent of forming a final composition from individual elements.

Left
SUE GOLLIFER, *UNTITLED G1*, 2000.
GICLÉE PRINT, 48.2 X 48.2 CM (19 X 19 IN)
By exploiting the uncertainty, rapidity and chaotic nature of computation, Sue Gollifer looks for unexpected results that will provide solutions to artistic problems and invite new discussions about the relationship between artist and viewer.

Below left
DONA J. GEIB, *REMNANTS OF THE SOUL*, 2003. DIGITAL PRINT AND ENCAUSTIC ON WOOD PANEL WITH METAL AND GOLD LEAF, 45.7 X 45.7 CM (18 X 18 IN)
Dona J. Geib started working with digital methods in 1976, having been a traditional printmaker up to that point. She now uses digital cameras to gather the source images for her works, which she then combines and reshapes using digital technology before they are output as digital prints and further elaborated.

Opposite
LAURENCE GARTEL, *CONEY ISLAND BABY*, 1999.
INKJET PRINT, 147.3 X 182.9 CM (58 X 72 IN)
With a background as a photographer and videographer, Laurence Gartel began experimenting with video synthesizers and digital images in the mid-1970s. He was one of the first artists to explore digital imaging and photo manipulation. Gartel's works are inspired by visits to particular places, but then assume layers of complexity as he manipulates them into their final form.

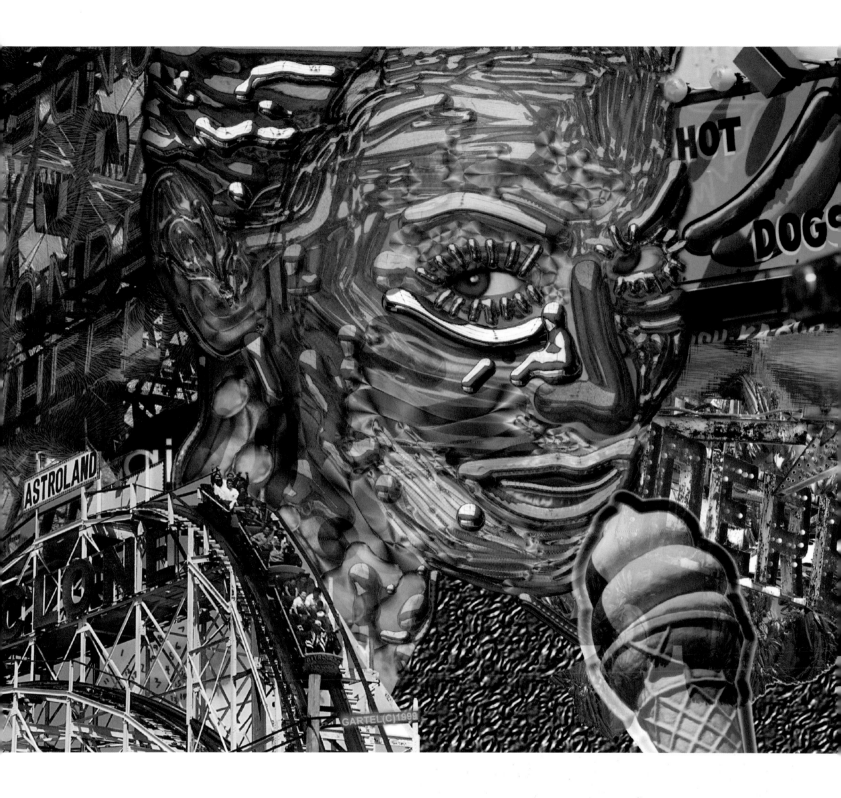

NEVER IN THE HISTORY OF THE WORLD HAVE WE SEEN SUCH CHANGES IN THE WAY OUR SOCIETY RECEIVES AND PROCESSES INFORMATION. OUR THOUGHTS AND METHODOLOGIES ARE EVOLVING ALMOST ON A 'REAL TIME' BASIS. AS AN ARTIST WHO HAS WORKED IN THE ELECTRONIC MEDIUM FOR OVER THIRTY YEARS I HAVE WITNESSED MANY OF THESE CHANGES FIRST-HAND.
LAURENCE GARTEL

Left
ISAAC KERLOW, *BLUE PEARL*, 1998. INKJET PRINT, 27.9 X 83.8 CM (11 X 33 IN)
Coming from a background in traditional printmaking, in the 1980s Isaac Kerlow began to explore the possibilities of combining these techniques – etching, engraving and silkscreen – with computer-generated imagery.

Opposite
HELEN GOLDEN, *MOLTEN ELEMENTS*, 1999. MIXED-MEDIA, 73.6 X 53.3 CM (29 X 21 IN)
Helen Golden can be described as a traditional artist who uses digital tools. She feels that the addition of technology to her artistic repertoire has given her a more immediate access to her imagination, thereby enhancing her creative process.

I AM NOT ATTRACTED TO THE COMPUTER BECAUSE OF ITS ABILITY TO CREATE PERFECTION OR PURE GEOMETRY. MY INTEREST IN COMPUTERS IS TO GENERATE EMOTIONAL WORKS WITH A GESTURAL, UNPOLISHED QUALITY TO THEM.
ISAAC KERLOW

***MOLTEN ELEMENTS*, WHICH EXPLORES THE EMERGENCE OF A LIFE-FORCE AS EMBODIED BY THE TWO FIGURES, IS PART OF A SERIES OF IMAGES ABOUT RELATIONSHIPS. I SCANNED A WOODCUT PRINT AND SEVERAL PHOTOGRAPHS OF A POSING COUPLE, ONE OF A NILE SUNSET AND ONE OF LIGHT STREAKS FROM FLARES. USING COMPUTER ART-MAKING APPLICATIONS I COLLAGED AND PAINTED THE DIGITIZED INFORMATION.**
HELEN GOLDEN

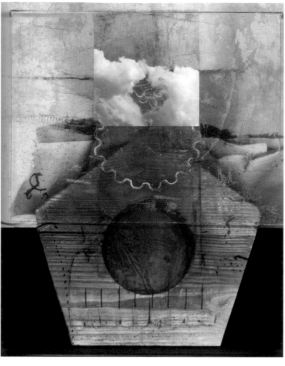

Far left
LINDA LAURO-LAZIN,
ARTIFACTS, **1995.**
DIGITAL PRINT, 28 X 21.6
(11 X 8½ IN)
This image, part of Linda Lauro-Lazin's *Pixels and Sticks* series, combines natural forms with pixilated patterns. The artist began using digital technology in 1986.

Left
BONNY PIERCE LHOTKA,
FENCELINE, **2003.**
INKJET ON PHOTO PLATE,
81.3 X 61 CM (32 X 24 IN)
With a background in printmaking and painting, Bonny Pierce Lhotka began her digital art explorations with an Apple II computer in 1982, initially to create black-and-white plates for block printing. This rich and colourful work is part of the *Aerial Essence* series, created with photographs taken from airplane windows and framed by a collection of objects from junkyards and flea markets.

SEEING THE WORK IS A VISUAL AND COGNITIVE EXPERIENCE WHICH EXPLORES OUR MOVEMENT, OUR STEREO-VISION AND OUR UNDERSTANDING OF SPACE AND DEPTH. DESPITE THE COMPLEXITY AND APPARENT CHAOS OF THESE THREE-DIMENSIONAL DRAWINGS, THERE ARE SIMPLE RULES THAT ORGANIZE THEM.
TONY LONGSON

Below left and right
TONY LONGSON, ***CHEETOS,***
1978–86. SCREEN PRINT ON
PLEXIGLAS (WITH DETAIL),
121.9 X 121.9 X 15.2 CM
(48 X 48 X 6 IN)
This work is formed by the relationship between patterns printed on layers of Plexiglas – achieved through Longson's use of rotational symmetry.

Opposite
DOROTHY SIMPSON
KRAUSE, ***REFLECTIONS,***
2003. INKJET PRINT ON
ALUMINIUM, 61 X 61 CM
(24 X 24 IN)
Dorothy Simpson Krause began her art career as a painter and collage-maker and started working with computers in the late 1960s. She received the Smithsonian Technology in the Arts Award for organizing 'Digital Atelier: A Printmaking Studio for the 21st Century' at the National Museum of American Art in 1997.

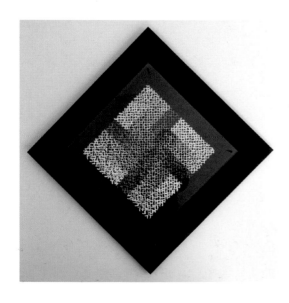

BY FOCUSING ON TIMELESS PERSONAL AND UNIVERSAL ISSUES – HOPES AND FEARS, WISHES, LIES AND DREAMS, IMMORTALITY AND TRANSIENCE – I CHALLENGE MYSELF AND THE VIEWER TO LOOK BEYOND THE SURFACE TO SEE WHAT DEPTHS ARE HIDDEN. I IMBUE MY WORK WITH THE QUALITY OF ALLEGORY.
DOROTHY SIMPSON KRAUSE

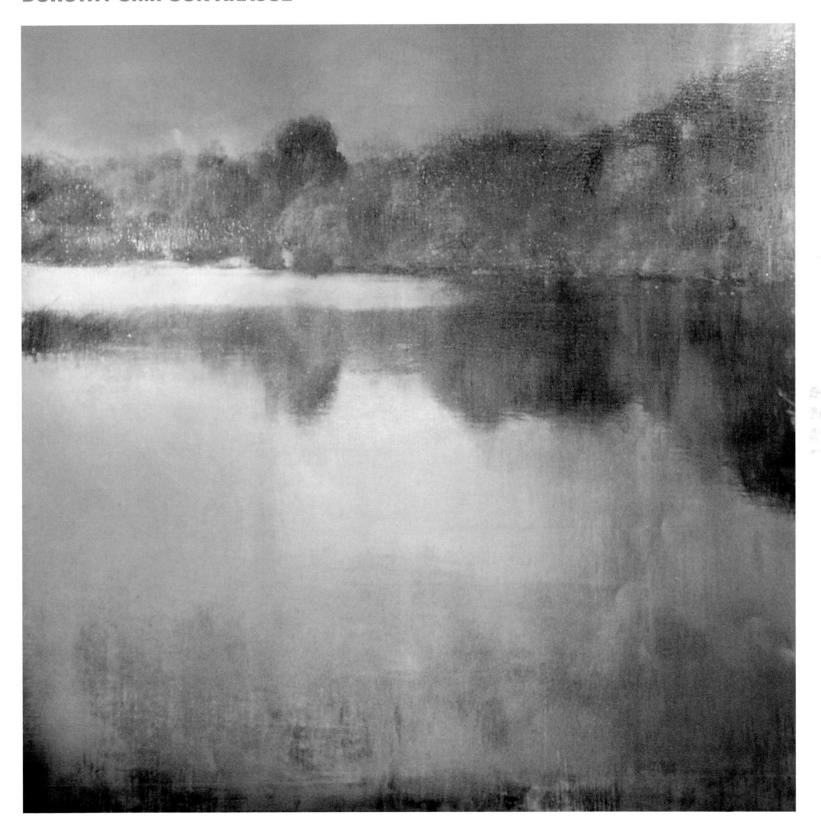

Above
JUAN ANTONIO LLEÓ,
***GEOMETRA 6P8C*, 2000–01.**
INKJET PRINT ON KODAK PAPER,
45 X 60 CM (17¾ X 23⅝ IN)
This work is from a collection of abstract images that
were created using the Asymetrix Web 3D software.
Juan Antonio Lleó is also known for his installation,
musical and multi-media work, as well as for his
collaborative projects (pp. 130–31).

Opposite
HILARY LORENZ, *CELLULAR STUDY 3*, 1999.
C-PRINT MOUNTED ON PLEXIGLAS,
53.3 X 175.3 CM (21 X 69 IN)
Hilary Lorenz here explores medical, scientific and
pseudo-scientific elements side by side. In so doing,
she invites us to consider the relationship between art
and science.

TO DEFINE A COMPLEX SYSTEM THAT GENERATES SOUND OR IMAGES AND MODULATE IT TO PRODUCE INTERESTING RESULTS, AND THEN COMBINE IT WITH OTHER ELEMENTS OR USE IT AS THE STARTING POINT FOR A NEW PROCESS, IS A KIND OF GAME THAT I LOVE TO PLAY. UNDOUBTEDLY, THE COMPUTER IS A PERFECT PARTNER FOR THIS. I THINK OF MY IMAGES AS ABSTRACT PICTURES IN MOTION, CHANGING, BUT NEVERTHELESS SIMILAR TO THEMSELVES.
JUAN ANTONIO LLEÓ

THE TENSION BETWEEN **ADDRESSES THE CONFLICT BETWEEN OPPOSING FORCES. WHEN THE IDEALS OF TWO ENTITIES CLASH, THE DISHARMONY CREATES A NON-PHYSICAL SPACE THAT ENGULFS BOTH PARTIES. BETWEEN THE PIERCING ANGER OF ATTACK AND THE CONVICTION OF ONE'S OWN BELIEFS, AN EXCLUSIVE, TRANSITORY WORLD IS CREATED. THIS OFFENSIVE YET CAPTIVATING SPACE OF VULNERABILITY AND STRENGTH HELPS TO ESTABLISH OUR INNER VOICE AND DEFINE OUR DIRECTION IN LIFE.**
BONNIE MITCHELL

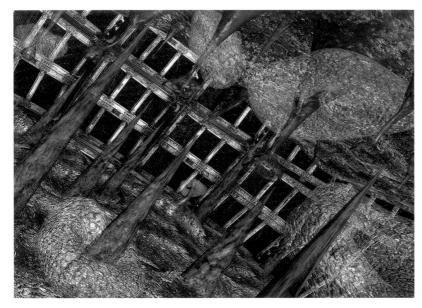 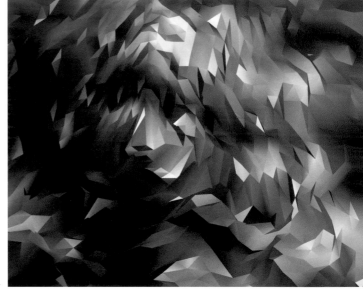

Above left
BONNIE MITCHELL, *THE TENSION BETWEEN*, **2000.**
INKJET PRINT, 76.2 X 106.7 CM (30 X 42 IN)
Bonnie Mitchell created this image using 3D modelling, particle systems and dynamics software. The artwork contains contrasting red and green elements that appear to consume and intermingle with amorphous yellow shapes. The textures have been created using digital photography manipulated in Photoshop and mapped onto the surface of the geometry.

Above right
MAUREEN NAPPI, *WELDED CHAMBER*, **2003. VIRTUAL THREE-DIMENSIONAL PAINTING, VARIABLE MEDIA AND DIMENSIONS**
Maureen Nappi's work is elegant, refined and complex. She combines a variety of techniques to make artwork that focuses on the relationship between humanity and technology, spiritualism, feminism and race. An advocate of new forms of art, Nappi was instrumental in creating a funding category for computer arts within the New York Foundation for the Arts.

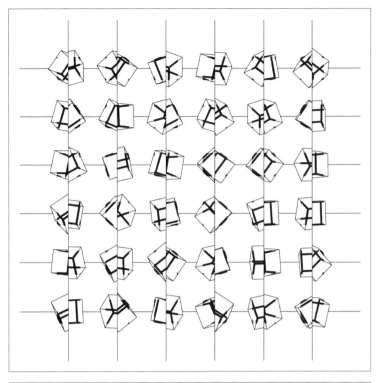

I WRITE COMPUTER ALGORITHMS, I.E. RULES THAT CALCULATE AND THEN GENERATE A WORK THAT COULD NOT BE REALIZED IN ANY OTHER WAY. IT IS NOT NECESSARILY THE SYSTEM OR THE LOGIC I WANT TO PRESENT IN MY WORK, BUT THE VISUAL INVENTION THAT RESULTS FROM IT. MY ARTISTIC GOAL IS REACHED WHEN A FINISHED WORK CAN VISUALLY DISSOCIATE ITSELF FROM ITS LOGICAL CONTENT AND CONVINCINGLY STAND AS AN INDEPENDENT ABSTRACT ENTITY.
MANFRED MOHR

Above left
MANFRED MOHR, *P-197K*, 1977. PLOTTER DRAWING, ACRYLIC INK ON CANVAS, 183 X 183 CM (72 X 72 IN)
In this example of Manfred Mohr's creative explorations, cubes are divided into two parts by one of the Cartesian planes. Each element of the split cubes is rotated independently, creating a broken symmetry. The final image is composed of an array of cubes in a 6 x 6 matrix.

Left
NANCY MCGEE, *CHROMOSCOPE SHIELD*, 2000. 78-TILE EPSON ARCHIVAL INKJET PRINT, 228.6 X 152.4 CM (90 X 60 IN)
Symmetry and pattern play an important role in Nancy McGee's work. This image from her *Survival Series* consists of seventy-eight vividly coloured genetic maps.

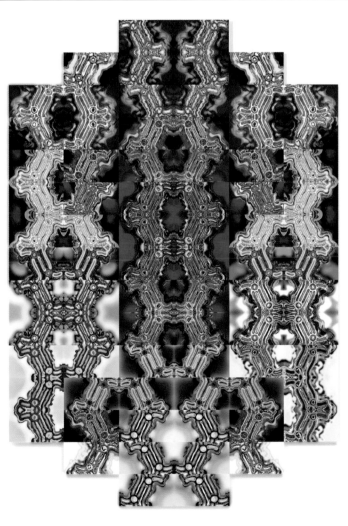

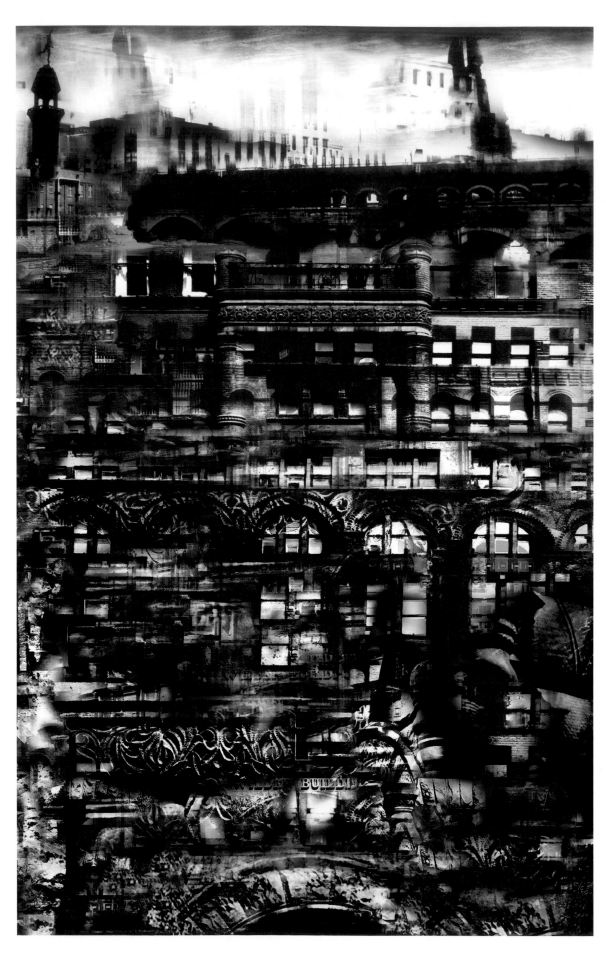

CYNTHIA BETH RUBIN,
THE WILDER BUILDING,
ROCHESTER, NY, **2002.**
DIGITAL PAINTING,
VARIABLE DIMENSIONS
The Wilder Building has special meaning for the artist, as it was where her father began his law practice. The combination of painting, digital collage and architecture is prevalent in Cynthia Rubin's interpretive work. Trained as a painter in the era of abstraction, she also works in web art, interactive installation and virtual reality.

MY WORK IS AN INVESTIGATION OF THE THREADS OF CULTURAL MEMORY, THAT I FEEL BOTH FROM MY OWN VISUAL EXPERIMENTS AND THROUGH THAT MYSTERIOUS TRANSMISSION OF SENSIBILITY THAT COMES FROM SOME PLACE BEYOND THE INDIVIDUAL. I AM INTERESTED IN HOW CULTURAL TRADITIONS COLLIDE AND MERGE, AND HOW THIS IS EMBEDDED IN ALL OF US.
CYNTHIA BETH RUBIN

JOSEPH NECHVATAL, *VIRAL COUNTER-ATTACK*, 2003. SCREEN CAPTURE, VARIABLE DIMENSIONS
Highly theoretical in his approach, Joseph Nechvatal creates large robot-assisted paintings on canvas and makes use of viral processes to develop the imagery. The dark areas on the left and right of this screen capture show the virus affecting the image.

JAN PAMULA, *IMAGE 019A*, 2001. DIGITAL PRINT, 50 X 60 CM (19¾ X 23⅝ IN)
Jan Pamula is an example of a painter and printmaker working with geometric abstraction who made a smooth transition to working in the digital realm. Geometry and colour form the structural basis of his work.

I WANT MY AUDIENCE TO EXPERIENCE THE INTIMACY OF THE FORMS AND TEXTURES I HAVE PHOTOGRAPHED OR DRAWN, AND TO EXPERIENCE MY FASCINATION WITH DETAIL, COMPLEXITY AND REPETITION. IN THIS ERA OF BEING WIRED, I WANT MY WORK TO SERVE AS AN OASIS OF CALM, AN INTROSPECTIVE RETREAT. MY WORK IS INTENDED TO BE UPLIFTING, A JOYFUL OBSERVANCE OF NATURAL FORMS TRANSFORMED INTO ICONS FOR MEDITATION AND CONTEMPLATION.
KARIN SCHMINKE

**KARIN SCHMINKE, *FORM:INFORM*, 2004.
DIGITAL/MIXED-MEDIA TRIPTYCH,
61 X 182.9 CM (24 X 72 IN)**
Karin Schminke draws her inspiration from the forms and patterns of nature. She works with mixed-media, combining photography, drawing and printmaking with digital techniques to produce images that suggest the power and mystery of the natural environment.

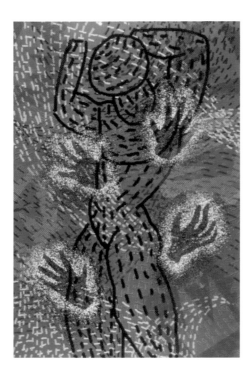

BARBARA NESSIM, *HAND MEMORY*, 1986. FUJIX COLOUR DIGITAL PRINT ON PAPER, 76.2 X 61 CM (30 X 24 IN)

Barbara Nessim comments that this piece was conceived after watching a television programme on prehistoric cave-paintings. She states, 'The programme made me wonder how far we have come, cave paintings to electronic art. *Hand Memory* addresses that thought.'

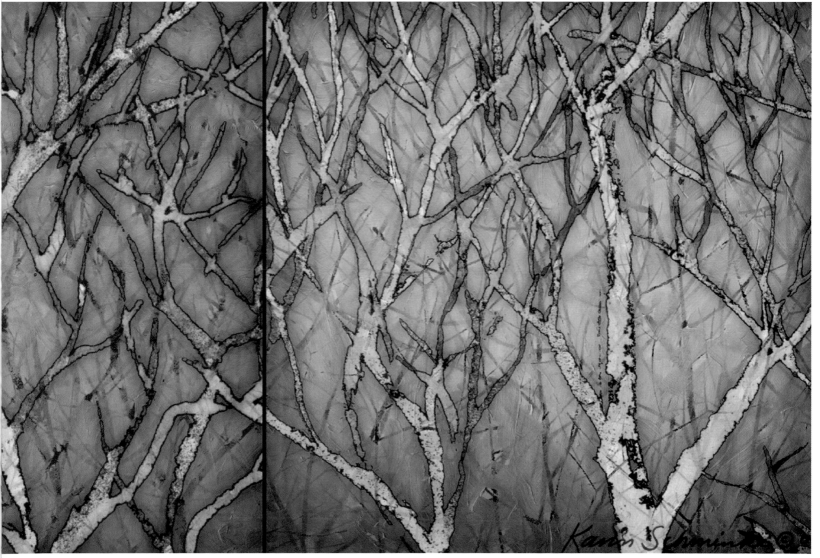

Below
ROMAN VEROSTKO, *CYBERFLOWER IV, GOLD VERSION*, 2000. ALGORITHMIC PEN-AND-INK DRAWING ON PAPER, 58.4 X 73.6 CM (23 X 29 IN)
One of the pioneers of algorithmic art, Roman Verostko has worked for more than twenty years with programming and pen plotters to create intricate and beautiful digital drawings. His interest in electronic art started in the 1960s, and he first began to experiment with algorithmic art twenty years later. Verostko is interested in creating what he calls 'form generators' and is influenced by the early 20th-century artists Mondrian, Kandinsky and Malevich.

Opposite
JOAN TRUCKENBROD, *ARTIFICIAL FRAME*, 1994. GICLÉE PRINT, 55.9 X 71.1 CM (22 X 28 IN)
Much like the process of revealing and concealing sacred symbols that are painted on one's body during a ceremony and visible in the flickering of firelight at night, Joan Truckenbrod's artwork uses light and the flow of colour fluids to sculpt the ecology of social environments.

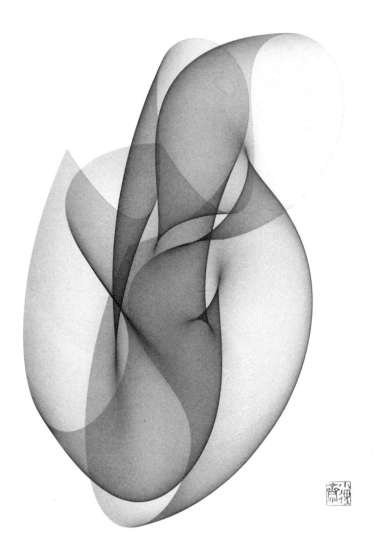

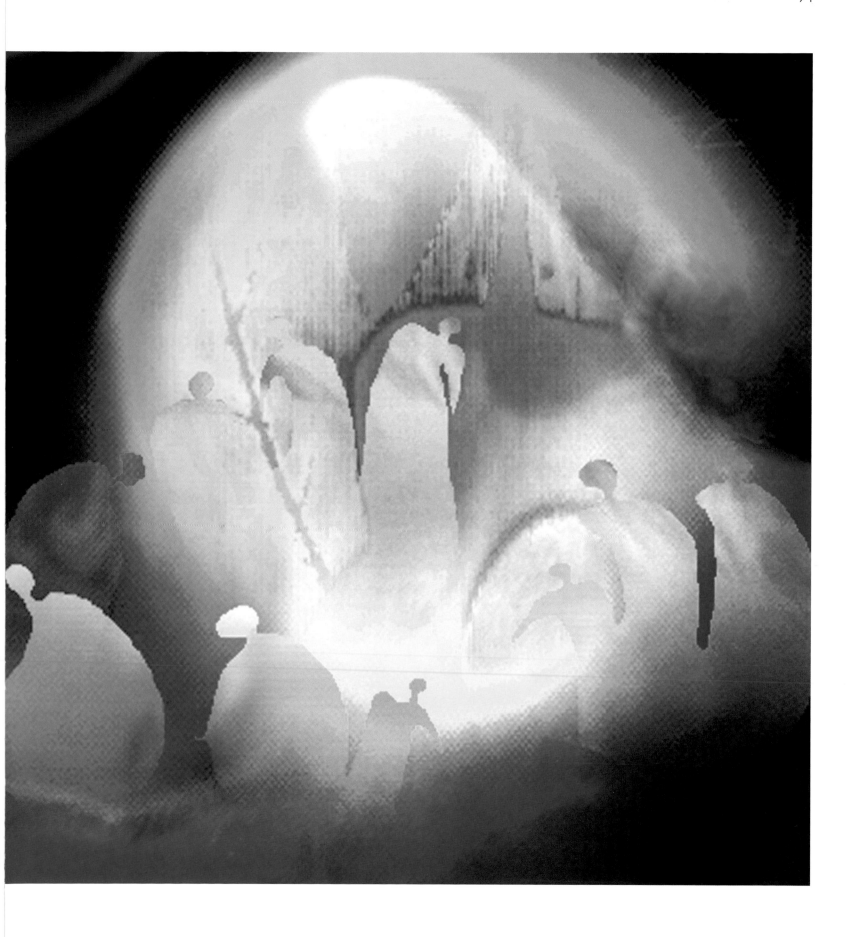

DIGITAL SCU LPTURE

The origins of digital sculpture can be traced back to the first practical applications of computers. Initially, computing was employed mainly in the areas of military defence and in computer-assisted drawing (CAD) and computer-assisted manufacturing (CAM), and the technologies were adapted early on for use by the aerospace and automobile industries. As modelling/animation software and hardware developed, their potential application in the field of digital sculpture became apparent.

As with most early computer technologies, artists had difficulty gaining access to the equipment. Nonetheless, they fully recognized the opportunities this medium presented and, even before facilities to fabricate digital sculpture were available, sculptors began to explore the use of three-dimensional software to design their sculptures and the new creative possibilities that it offered. Part of the appeal of these early computer simulations was that artists could create and visualize forms that were free from the natural constraints of weight, size or gravity: they could make three-dimensional works that were limited only by their own imagination. CAD/CAM also spawned computerized numerical control (CNC) milling and rapid prototyping, with which industrial designers and sculptors can make physical models of objects from three-dimensional software files. These technologies have since become affordable, and sculptors can now submit a three-dimensional digital file to a service bureau and have a physical model fabricated.

Sculptor Rob Fisher's interest in working with digital technologies (p. 92) sprang from a desire to see what different forms he could invent. While Fisher embraces the use of the computer in creating his work, he also continues to use traditional techniques, stating that 'In my latest artwork, I have in some ways come "full circle" and returned to traditional studio techniques, augmented, however, by the use of the computer. One should use the computer when it is appropriate: to save time or to permit development of forms that would otherwise be difficult by virtue of their complexity, engineering or scale.'

Some artists use digital technologies both in the design and in the physical creation of their works; some design on screen but adhere to

traditional methods of production; and others make sculptures that exist only in the virtual realm in the form of a three-dimensional model, image or animation. A number of works give no clues that they were produced using digital means, whereas others exhibit an intricacy or distortion that could have only been produced with a computer.

Sculptors using purely traditionally techniques begin by sketching and drawing their ideas from a variety of perspectives while developing the concept. When the drawings have been completed, models and maquettes are created in various sizes in order to refine the original concept. These creative experiments eventually evolve into the finished work. The choice of material clearly has an impact on the production process, since the sculpture might be carved from stone or cast from metal or other media. By using a computer, however, the artist can avoid the considerable costs involved in producing prototypes or, indeed, the final works themselves: the ability to make refinements in the digital realm gives artists the flexibility to embark on projects that may otherwise have been simply too complicated or expensive to take beyond the conceptual stage.

Virtual sculptures are created with three-dimensional modelling software and consist of a database of numbers that defines their shape, volume and surface properties. Many software applications to create digital sculpture are available, Alias Maya being one of the most sophisticated. First, the sculptural objects are created and visualized in a 'wire frame' mode, to which surfaces are then applied in the form of a 'skin'. Sculptors examine their work from any viewpoint and select from a wide variety of surface properties – such as stone, metal and plastic or any other material – all of which can be applied or changed quickly and easily. They can also modify the look of the sculpture immediately as they work, which aids in its conceptual development. If a sculptor had to execute these drawings and visualizations by hand, it would take a considerable amount of time and require significant rendering skills on the part of the artist. Many digital sculptors admit that the computerized design process can be as time-consuming as its traditional counterpart, but note that by using the computer as a visualizing tool they can dedicate much more time to refining their ideas.

The ability to create a three-dimensional object in cyberspace offers the sculptor tremendous scope. With physical constraints lifted, forms can take unique and complex shapes. Surface properties, such as colour, texture and reflectivity, can also be further manipulated and are not, as in physical sculpture, limited to the chosen material. Since the sculptural file resides in a computer, it can be sent to and accessed from remote locations over the internet. Sculptors can also use photo-imaging software to modify photographs and 'insert' their sculpture in a wide variety of environments – a substantial advantage when designing site-specific installations.

One of the first sculptors to use three-dimensional software was Kenneth Snelson (pp. 86–87), who explored this area in the early 1990s. Snelson's sculptures incorporate the interplay of tension and compression, reflecting his embrace of the mathematical concept that he calls 'tensegrity'. Snelson likens his sculptures to musical compositions in which the elements interact

I HAVE BEEN USING THREE-DIMENSIONAL DIGITAL MODELLING TO CREATE MY SCULPTURES SINCE 1987. I USE IT LIKE A THREE-DIMENSIONAL DRAWING PAD THAT ALLOWS ME TO WORK ON THE SCULPTURE FULLY IN THE ROUND, BUT VERY SPONTANEOUSLY. WHEN MODELLING DIGITALLY, I CAN SAVE INTERESTING ACCIDENTS OR NEW IDEAS THAT DEVELOP AND RETURN TO THEM LATER AS THE BEGINNING OF A NEW PIECE.
BRUCE BEASLEY

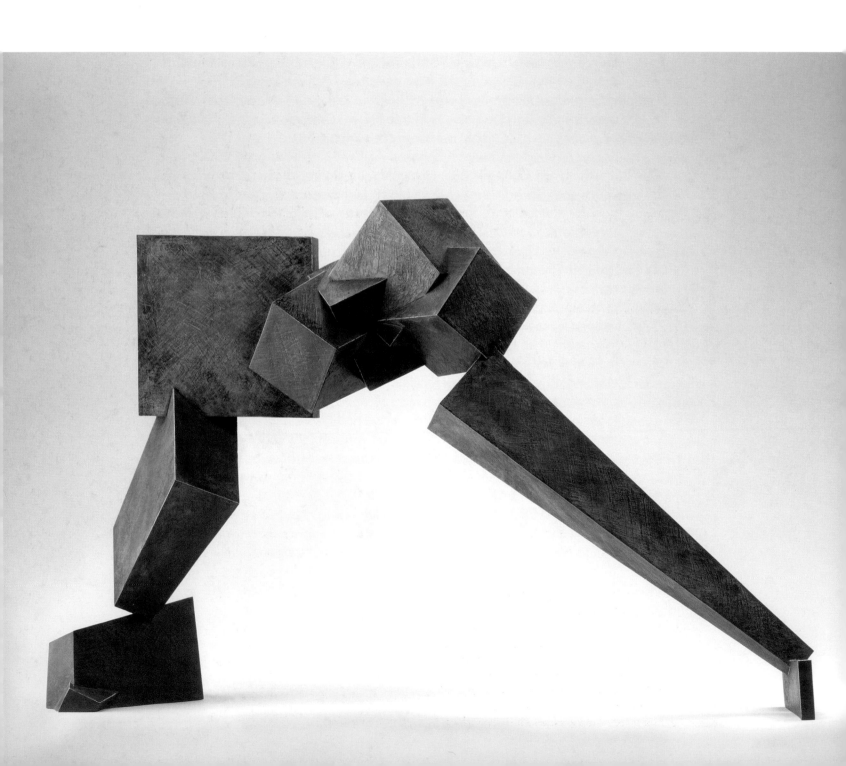

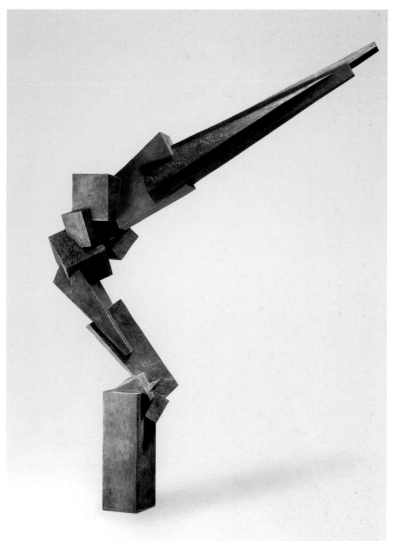

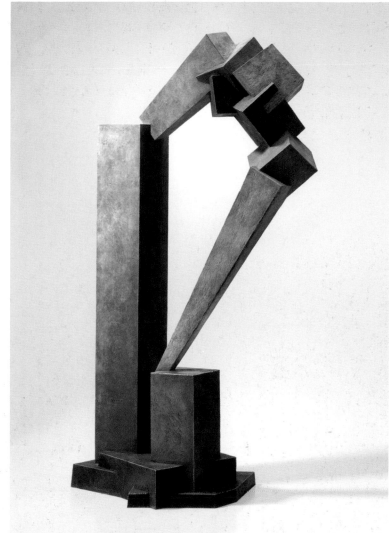

Opposite
**BRUCE BEASLEY, *BREAKOUT*, 1991. CAST BRONZE,
71.1 X 111.8 X 30.5 CM (28 X 44 X 12 IN)**

Above left
**BRUCE BEASLEY, *OUTREACH*, 1998. CAST BRONZE,
104.1 X 71.1 X 25.4 CM (41 X 28 X 10 IN)**

Above right
**BRUCE BEASLEY, *INSURGENT*, 2001. CAST BRONZE,
127 X 63.5 X 45.7 CM (50 X 25 X 18 IN)**

Bruce Beasley's sculptures are based on the geometric shapes that he
creates with his computer. Those shown here are cast in bronze, although
he has also worked in cast iron, aluminium, acrylic and wood. Beasley
maintains that he would produce the same type of sculpture with or
without the computer, but recognizes that the computer allows him to work
more quickly and intuitively. Rather than spend enormous amounts of time
building physical models, he instead uses the software to refine his ideas.

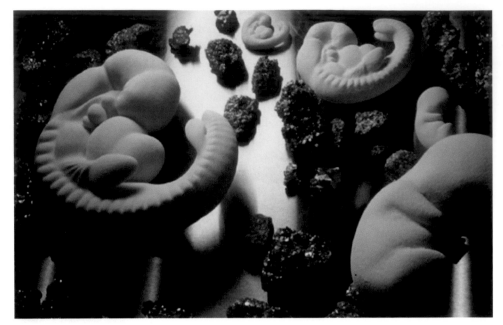

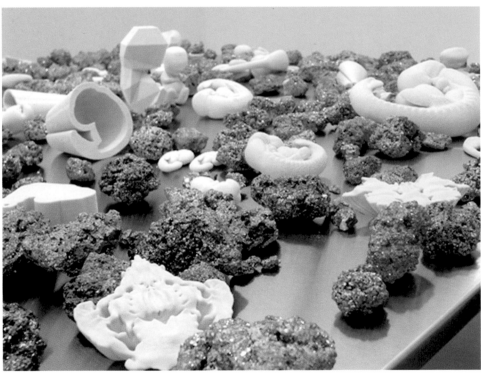

SUZANNE ANKER, *ORIGINS AND FUTURES***,
2004. RAPID PROTOTYPE SCULPTURES,
PYRITE AND STAINLESS STEEL, INSTALLATION,
VARIABLE DIMENSIONS**
Suzanne Anker works in a variety of media and
addresses the relationship between art and genetics.
In this mixed-media installation, rapid prototype
sculptures of embryos, 3D Rorschach inkblot images
and other abstract forms reside among pieces of pyrite
on a steel table.

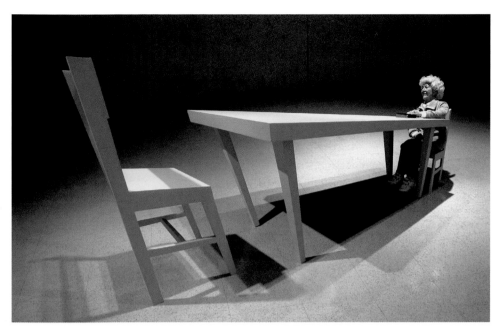

DAN COLLINS, *SPEAKING LIKE ADULTS*,
1993–2003. MIXED MEDIA,
110.5 X 243.8 X 91.4 CM
(43½ X 96 X 36 IN)

The focus of this work is an exact half-scale likeness of Dan Collins's mother set at one end of an anamorphically distorted table. The data set for the head was captured using a Cyberware 3D laser digitizer. The model of this head was subsequently rendered in proprietary software, and then cut using a CNC mill. A silicone mould was used to create a hollow head, which was then painted with acrylics and completed with a wig made from natural mohair. This juxtaposition between reality and virtuality is at the heart of Collins's creative approach.

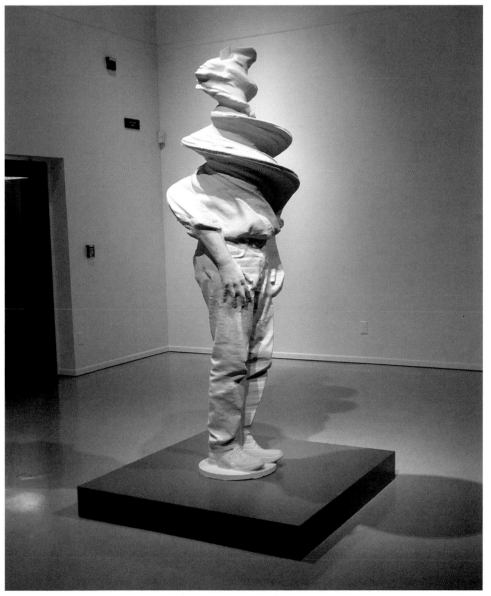

DAN COLLINS, *TWISTER*, 2003. CNC-MILLED
URETHANE, 243.8 X 76.2 X 76.2 CM
(96 X 30 X 30 IN)

This sculpture is a self-portrait. The data set was generated in 1995 using a Cyberware full-body laser scanner. The artist stood on a turntable that was spun by his wife. The movement captured during the initial part of the scan produced the distorted results; by the time the scanner reached his waist, he had stopped spinning. The data was then output to a custom CNC milling machine to create the final sculpture.

DAN COLLINS, *RETURN TO THE GARDEN,* **2003. NETWORKED VIDEO INSTALLATION, CNC-CUT WOODEN PARTS, NETWORKED COMPUTER, PRINT, MONITOR. ROOM SIZE APPROXIMATELY 3.7 X 9.1 X 9.1 M (12 X 30 X 30 FT)**
At first glance, this installation appears to be a chaotic assemblage of black silhouettes. When one looks at the camera view, either on the internet or on the laptop in the gallery, the video images resolve into landmark moments from mythology and the history of flight. They include silhouettes of Icarus, Otto Lilienthal, the Hindenburg, the Space Shuttle Challenger, a Boeing 767 and a Blackhawk helicopter. Viewers can select a series of 'presets' that direct the camera to the images. Dan Collins's intention is for viewers to question the truth of images, the power of machines and the seduction of handmade objects.

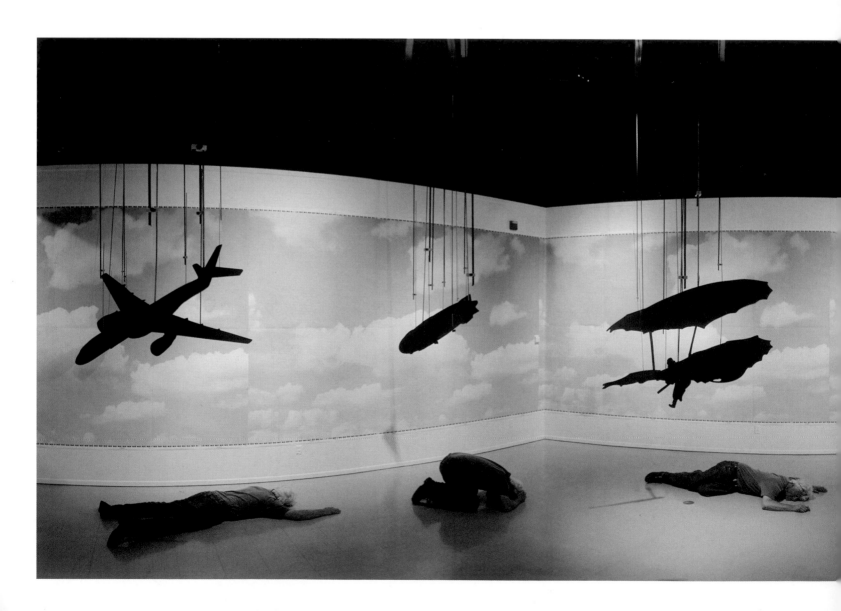

MY CURRENT SERIES OF WORK UTILIZES COMPUTER MODELLING TO CONTROL THE KIND AND DEGREE OF DISTORTION IMPOSED ON A GIVEN OBJECT OR DATA SET. SCALING OPERATIONS, PROPORTIONAL SHIFTS, ECCENTRIC VANTAGE POINTS, MORPHING PROCESSES AND THREE-DIMENSIONAL MONTAGE ARE SOME OF THE TECHNIQUES EXPLORED BY THIS BODY OF WORK. PART OF THE CHALLENGE HAS BEEN TO GET FORMS 'OUT OF THE BOX' (THE COMPUTER) AND FULLY REALIZED IN AN ACTUAL, TANGIBLE FORM. I AM INTERESTED IN THE GAP BETWEEN THE VIRTUAL SPACE OF THE COMPUTER AND THE TANGIBLE, BODY-FELT REALITY OF SCULPTURAL OBJECTS.
DAN COLLINS

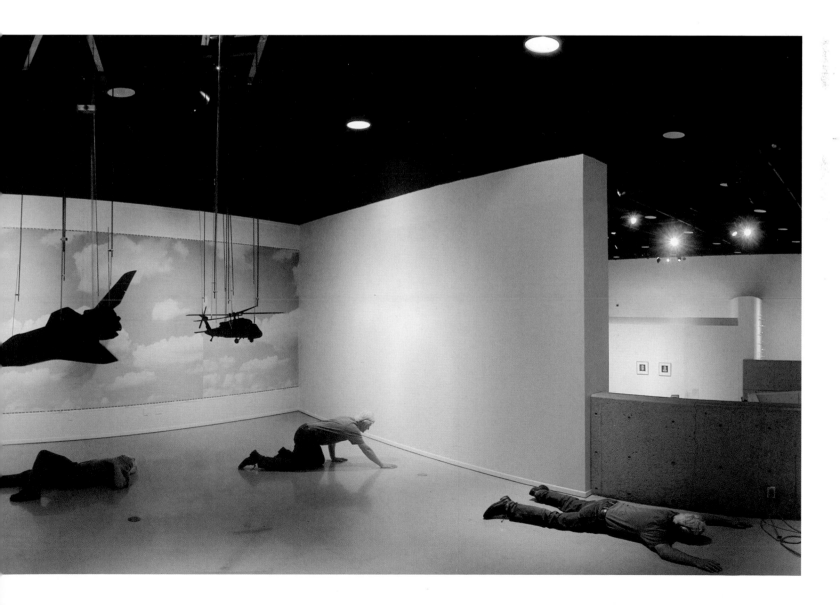

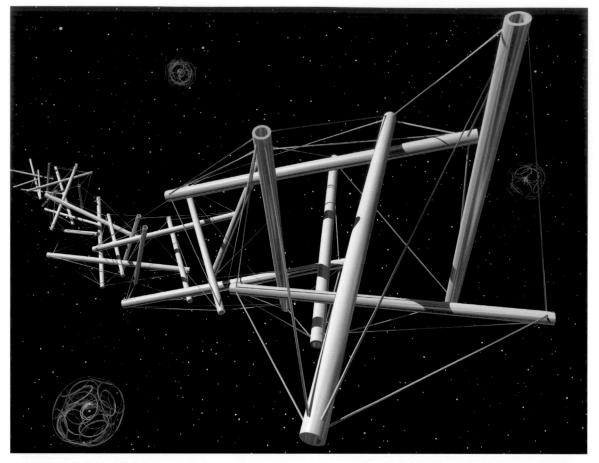

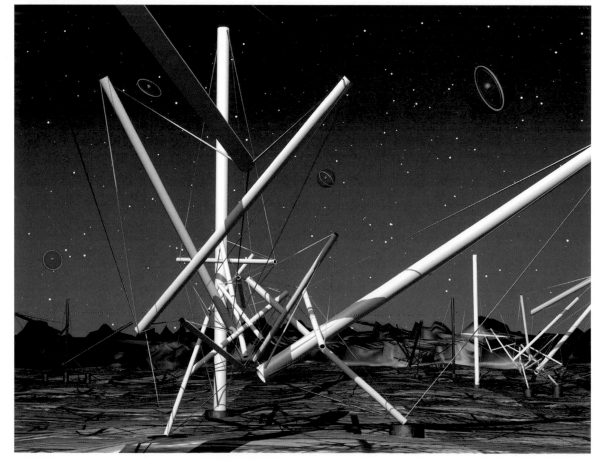

Left
KENNETH SNELSON, *STAR LANDING*, 1990. DIGITAL PRINT, 76.2 X 95.3 CM (30 X 37½ IN)

Below left
KENNETH SNELSON, *FOREST DEVILS' MOON NIGHT*, 1990. DIGITAL PRINT, 76.2 X 95.3 CM (30 X 37½ IN)

Opposite
KENNETH SNELSON, *CHAIN BRIDGE BODIES*, 1991. DIGITAL PRINT, 76.2 X 101.6 CM (30 X 40 IN)
Kenneth Snelson is one of the most well-known and influential contemporary artists working with sculpture, mathematics and photography. His early interest in Constructivism and geometric art led him to study with Buckminster Fuller at Black Mountain College in 1948. This experience clarified his aesthetic concepts and he began to incorporate principles of tension and compression into his work rather than follow Fuller's fascination with pattern and structure. Having worked mainly with mathematics early in his career, he made a smooth transition to the use of computers. The works shown here are some of the earliest examples of virtual sculpture.

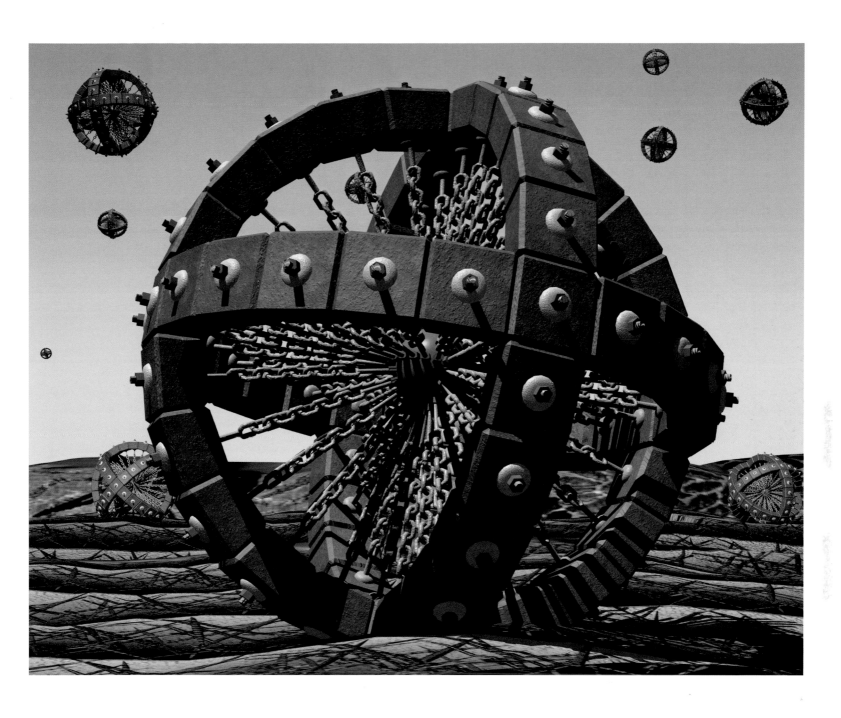

MY ART IS CONCERNED WITH NATURE IN ITS PRIMARY ASPECT, THE PATTERNS OF PHYSICAL FORCES IN THREE-DIMENSIONAL SPACE.
KENNETH SNELSON

ANNA URSYN, *HERO HORSE*, 1989. COMPUTER-ENHANCED SCULPTURE, 63.5 X 53.3 X 78.7 CM (25 X 21 X 31 IN)
Anna Ursyn's work explores the relationship between the human and animal worlds, juxtaposing natural environments (such as the forest floor shown here) with man-made constructions, and incorporating carefully manipulated prints on paper and canvas into the final structures.

FIRST, I SKETCH A GENERAL OUTLINE FOR THE COMPOSITION, AND THEN I DRAW ABSTRACT GEOMETRIC DESIGNS AS A STARTING POINT FOR THE EXECUTION OF MY COMPUTER PROGRAMMES. THE WIRE-FRAMED THREE-DIMENSIONAL DESIGNS GUIDE CONSTRUCTION, WHILE IMAGES – MULTIPLIED, SUPERIMPOSED, TRANSFORMED – OFFER THE ILLUSION OF TIME AND MOVEMENT. I USE THE VISUAL LANGUAGE OF THESE PROGRAMMES TO SHOW AN IMAGE OF THE HORSE AS A HEROIC SYMBOL OF THE HUMAN STRUGGLE FOR SURVIVAL.
ANNA URSYN

**PETER TEREZAKIS, *SOUND BLINKER*, 1983.
WEARABLE ELECTRONIC SCULPTURE,
5 X 5 CM (2 X 2 IN)**
This small pin incorporates circuitry both as an
aesthetic element and to control the LEDs that blink
in response to sound or conversation. It forms part
of a series that he began in 1976, when he designed
a small LED pin for actress Claudette Colbert.

**JAMES SEAWRIGHT, *ORION*, 2002.
DIGITAL INTERACTIVE SCULPTURE, METAL,
PLASTIC, ELECTRONIC COMPONENTS,
30.5 X 30.5 X 25.4 CM (12 X 12 X 10 IN)**
James Seawright began making electronic sculptures
in the 1960s, working with analogue circuitry, some
of which originated from electronic music processes.
One of the attractions for Seawright was the potential
for interaction between the work, various
environmental factors and viewers. By the mid-1970s,
he became involved with microprocessors and built
digital circuits to control his interactive sculptures.

**JAMES SEAWRIGHT, *HOUSE PLANTS*, 1984.
DIGITAL INTERACTIVE SCULPTURE, METAL,
PLASTIC, ELECTRONIC COMPONENTS,
APPROX. 152 X 152 X 61 CM (5 X 5 X 2 FT)**
House Plants, an early example of cybernetic botany
by pioneer James Seawright, was composed of
electronic 'plants' that exhibited robotic behaviour
in response to changing light levels and other stimuli.
The 'petals' moved up and down, and lights on the
plants were programmed to flash in various patterns.

Below left
**ROB FISHER, *PROTOS*, 2001. STAINLESS STEEL, ALUMINIUM,
4.6 X 4.6 X 4.9 M (15 X 15 X 16 FT)**
This work was inspired by a round doorway in an ancient garden
in Suzhou, China. Rob Fisher describes it as 'exploring relationships
between container and contained, between the simple but primal
character of the circular spiralling form and the complex complementary
sculptural elements within'. The central element is kinetic and is moved
by the power of the wind. Both digital and traditional methods were
used in its design and construction: the central form was fashioned from
styrofoam, while the helical form was rendered using 3D software.

Below right
**ROB FISHER, *DIHEDRALS*, 2002. ALUMINIUM FLAGPOLE
MASTS, STAINLESS STEEL NET AND RIGGING, ALUMINIUM
KINETIC ELEMENTS, 7.6 X 9.1 X 9.1 M (25 X 30 X 30 FT)**
Dihedrals (named after the geometric shape used to describe winged
objects such as birds and planes) is a large-scale kinetic sculpture
designed to sway and shimmer in the wind. Rob Fisher used both CAD
and engineering software to calculate the structural properties of the
sculpture and to ensure that it was capable of withstanding hurricane-
force gales.

CHRISTIAN LAVIGNE, *L'AGE DU FER*, 2002. CRYSTAL 3D LASER ENGRAVING, 10 X 10 X 12 CM (4 X 4 X 4¾ IN)

Christian Lavigne, a pioneer of digital and virtual sculpture, is credited with producing the first piece of rapid prototype sculpture in France, in 1994. Lavigne is typical of many digital artists in that he has a diverse background including science, mathematics, poetry and art. He co-founded Ars Mathematica, an international group of artists that promotes new technologies in sculpture, in 1992, and three years later co-founded 'INTERSCULPT '95', a worldwide biennial for interactive and simultaneous digital sculpture. This image is a 3D laser engraving produced in a block of crystal. Lavigne combines geometric shapes with figurative elements to create complex yet delicate constructions.

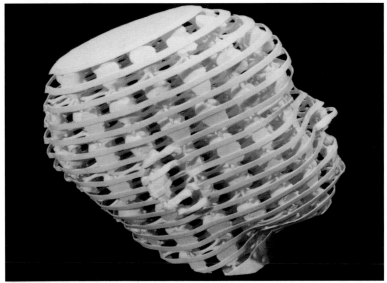

CHRISTIAN LAVIGNE, *CYBERSALY 3: LE SECRET DE L'ETRE*, 2002–03. SLS POLYAMIDE, 33 X 34 X 26 CM (13 X 13⅜ X 10¼ IN)

This intricate bust, pierced through and enveloped in ribbon-like contours, could only have been reproduced using rapid prototyping techniques.

**MARK MILLSTEIN, *FREQUENCY KITE 2*, 2003. INKJET ON
MULBERRY PAPER, BAMBOO, STRING. 61 X 45.7 CM
(24 X 18 IN)**

Mark Millstein began to design kites as a way to 'get the digital image
out of the frame' and to unite computer-designed images with sculpture
and handwork. 'The partnership of digital design and printing with the
activity of folding and gluing paper, and cutting and bending bamboo,
is a contemplative combination that is particularly fulfilling', he states.

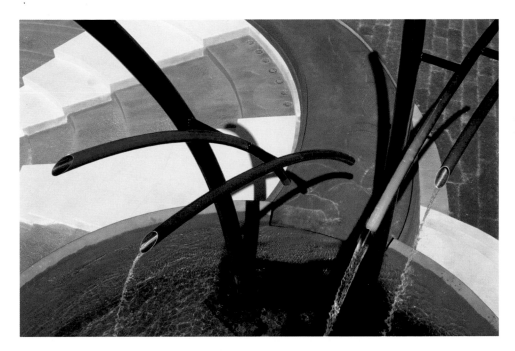

Left and below
DAVID CURT MORRIS, *RAINMAKER*, 2001. KINETIC WATER SCULPTURE, HEIGHT 13.7 M (35 FT)
Sculptor David Curt Morris uses water as an integral part of his work. He often employs 3D images and computer animation when planning projects in order to give an accurate rendition of what a sculpture will look like and how it will function.

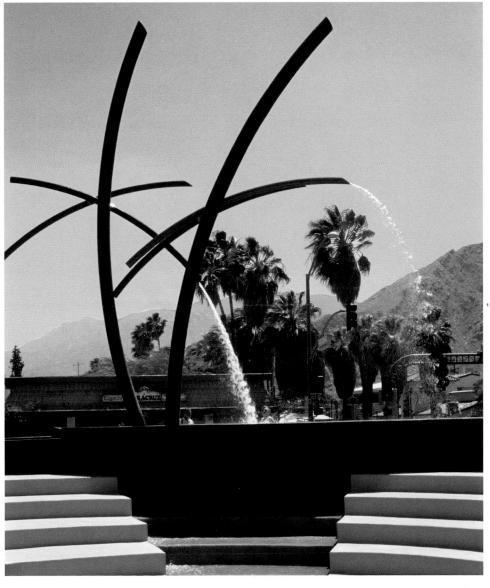

IT IS NOW POSSIBLE FOR AN INDIVIDUAL DESIGNER TO INCREASE PRODUCTION SPEED BY SIMULATING A TEAM THAT WOULD ACCOMPLISH MODELLING, ENGINEERING AND PRESENTATION. THE INVESTIGATIVE PATHWAY HAS BEEN WIDENED FOR AN EXPLORATION OF MATHEMATICAL FORMS, WHICH WAS IN THE PAST AN ARDUOUS JOURNEY. IT IS NOW POSSIBLE TO DREAM AND CONFIRM ALL IN THE SAME SETTING.
DAVID CURT MORRIS

WHERE OTHERS WORK WITH CLAY OR CARVE MARBLE, I USE ZEROS AND ONES, SHOWN AS PHOSPHORESCENT ELECTRONS ON A MONITOR, TO CREATE EPHEMERAL FORMS THAT ARE LATER FABRICATED INTO SOLID SCULPTURES. THE DIGITAL SCULPTURES ARE CREATED ON POWERFUL PCs WITH CAD SOFTWARE. THEY ARE THEN HANDCRAFTED AND MOULDED. THE FINAL SCULPTURE IS FABRICATED OF A MATERIAL CREATED BY NASA FOR THE SPACE SHUTTLES AND THEN HAND-DIPPED INTO AUTOMOBILE LACQUER DOZENS OF TIMES UNTIL THE SMOOTH WHITE FINISH IS ACHIEVED.
CORINNE WHITAKER

Below left
CORINNE WHITAKER,
NEW BEGINNINGS, 2001.
DIGITAL SCULPTURE

Below right
CORINNE WHITAKER,
SCULPT 1.3.00D, 2000.
VIRTUAL SCULPTURE
Best known for her 'blobs' – sensuous, organic forms – Corinne Whitaker uses both virtual and physical sculpture to invent a new visual and geometric language.

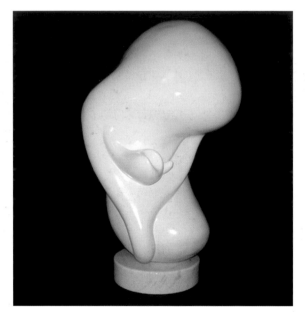

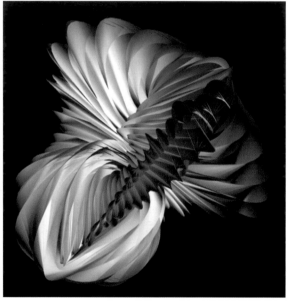

Opposite above
ROBERT MICHAEL SMITH,
EPHESIANCYBERGIN, 2003.
CNC-CUT MARBLE,
45.7 X 61 X 45.7 CM
(18 X 24 X 18 IN)

Opposite below
ROBERT MICHAEL SMITH,
GYNEFLEUROCERAPTOR,
2003. CNC-CUT MARBLE,
61 X 45.7 X 45.7 CM
(24 X 18 X 18 IN)
The forms created by Robert Michael Smith in both his sculptural work and prints exhibit a strong biomorphic quality. Smith, who has been involved with digital sculpture since the early 1990s, uses CNC milling to reproduce the whorls and curves of organic shapes in the traditional medium of marble.

ART IS ALCHEMY. ALCHEMY IS THE MAGIC, OBSERVATION, PROCESS AND RITUAL OF LIFE. MY SCULPTURES, BOTH VIRTUAL AND ACTUAL, ARE CONVERSATIONS REGARDING THE ARCHETYPAL FORMS THAT ARE THE BASIC STRUCTURES OF NATURE. I BUILD ALIEN ABSTRACT WORLDS THAT BECOME FAMILIAR THROUGH FREQUENT IMMERSION. THESE WORLDS ARE CONSTRUCTED TO OPEN EXPLORATION TO THE DEEPEST REGIONS OF THE HUMAN PSYCHE FOR DEVELOPMENT WITHIN THE LANDSCAPE OF THE IMAGINATION.
ROBERT MICHAEL SMITH

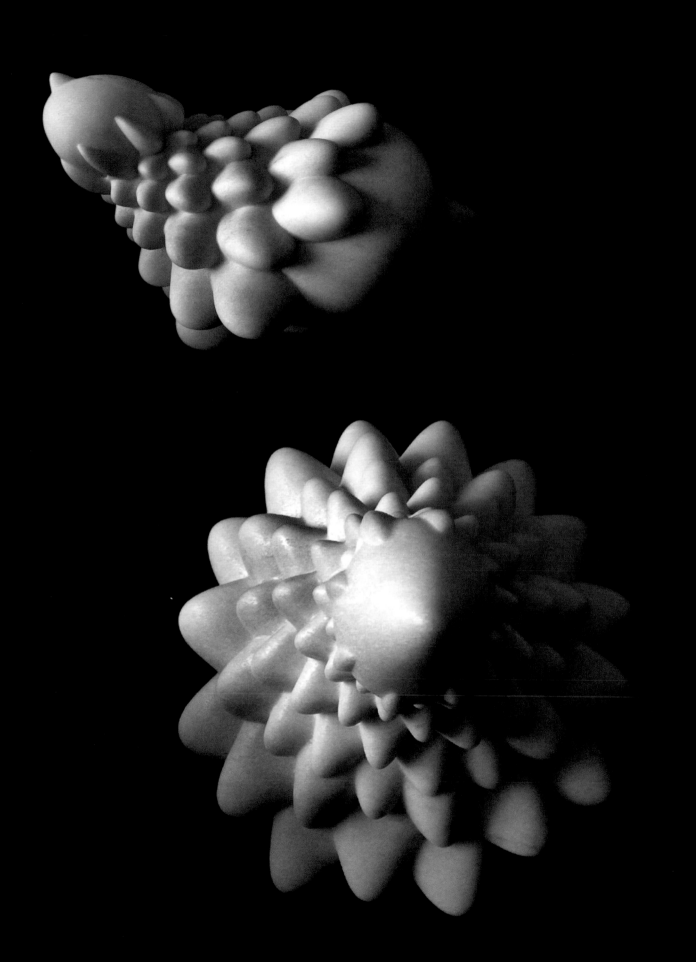

be remembered that although the computer has had an enormous influence on this type of creative work, there continues to be no clear-cut distinction between analogue and digital installation art. Installation artists simply use whatever technology is available to them, or whichever they prefer, to further their artistic endeavour, and a host of interfaces has been developed by artists for incorporation into installations.

The installation and virtual reality artists' studios

An almost paradoxical relationship exists between installation and virtual reality artists and their studios. Since installation is site-specific and virtual reality is computer-based, to some extent the 'studio' or creative realm of these artists is the public space or cyberspace where their work finds final expression. Installation covers a very broad range of work, and its creators incorporate diverse materials into their art. A digital installation artist's studio will therefore not be radically different from that of a traditional installation artist, aside from the addition of a computer and perhaps some computer-assisted manufacturing equipment and/or an electronics bench. Since the software and hardware used are quite elaborate, virtual reality art is generally a collaborative project between artist and programmer and often involves a larger creative team. Presently, virtual reality hardware and software still remain at the very high end of computing. However, the gap between virtual reality systems and personal computers has begun to narrow, making these technologies even more accessible to artists and their audiences. For example, in 2002, Char Davies ported two of her seminal works to the PC platform from a high-end computing environment.

The practitioners

The artists in this chapter represent a broad range of approaches to installation and virtual reality art. Char Davies, a pioneer of this art form, describes her immersive virtual reality environments *Osmose* (p. 29) and *Ephémère* (pp. 104–05) as works 'known for their embodying interface, painterly aesthetic and evocation of landscape'. Classics of their genre, they completely absorb the viewer in alternative worlds. Jeremy Gardiner also approaches virtual reality from a painterly perspective. In his *Purbeck Light Years* (pp. 108–09), the participant uses a video-game engine to navigate a three-dimensional landscape that incorporates the artist's paintings as well as the elements of time and weather. Mathieu Briand's work explores the virtual world through video headsets and transmitters. In *SYS*05.ReE*03/SE*1\ MoE*2-4* (p. 102), viewers are able to 'see through each other's eyes' by the transmission of a video image from one person's headset to a small screen in the other participant's headset. Grahame Weinbren's installations invite us to explore and to rethink the world of cinema. The viewer is able to interact with the works, which offers a sense of partial authorship during the experience. While *Erl King* and *Sonata* are based on narrative, in *Frames* (p. 116) Weinbren invites the viewer to engage with the artwork's characters, who are based on Hugh Diamond's 19th-century photographs of psychiatric patients.

While virtual reality and digital cinema draw the participant into the content of the work, other installation artists use architectural elements and public space as the venue for their art. Shih-Chieh Huang constructs environments with various materials, including plastic sheeting, bottles and tubing, and then animates them through sensor-controlled fans, pumps and other electronic equipment (pp. 102, 113). Different lighting schemes are also used to add an other-worldly atmosphere. Erwin Redl uses large-scale light installations as architectural elements with which he constructs virtual reality spaces (what he calls 'reverse engineering'), thus creating the effect of a virtual space without the complex hardware and software interfaces normally required (pp. 119–21).

Other artists straddle the borders between print and installation. For example, Diane Fenster prints images on fabric and then creates an environment with these images in a gallery space (p. 106), while artists such as Ian Haig (p. 112) and Federico Muelas (p. 119) build installations in which multiple technologies are employed to engage the viewer.

Anticipating the future possibilities of installation art is exciting, as new technologies continue to emerge that will enable even greater control over these created environments. It is likely that wall-size LCD panels will soon be available to artists, as well as other technologies that we have not yet imagined. Irrespective of individual concepts, approaches or techniques, installation and virtual reality are vibrant forms of contemporary art. The digital perspective has brought artists who work in these areas powerful tools and new sources of creative expression.

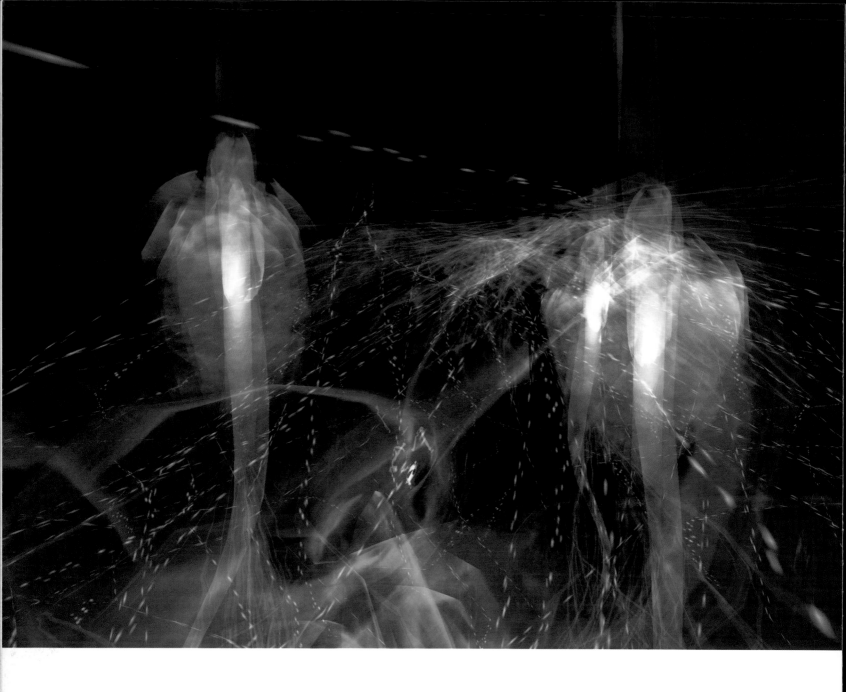

MY GOAL IS TO USE IMMERSIVE VIRTUAL SPACE TO COLLAPSE THE BOUNDARIES BETWEEN SUBJECT AND OBJECT, INTERIOR AND EXTERIOR, AND SELF AND OTHER. IN DOING SO, MY INTENT IS TO REFRESH OUR PERCEPTION OF BEING IN THE WORLD. I WANT TO RESENSITIZE PARTICIPANTS TO THE EXTRAORDINARINESS OF BEING ALIVE, SENTIENT AND EMBODIED, HERE NOW AMONG ALL THIS, IMMERSED AS WE ARE SO BRIEFLY IN THE FLOW OF LIFE THROUGH SPACE AND TIME.
CHAR DAVIES

Opposite
CHAR DAVIES, *SEEDS*, 1998. DIGITAL STILL IMAGE CAPTURED DURING IMMERSIVE PERFORMANCE OF THE VIRTUAL ENVIRONMENT *EPHÉMÈRE*

Ephémère is experienced by wearing a stereoscopic head-mounted display and a motion-tracking vest to record the participants's breath and balance, enabling him or her to float through its virtual realms. It is spatially structured along 3 vertical levels: landscape, under-earth and interior body, and also uses gaze to interact, causing elements to respond to the visitor. Each exploration is unique: *Ephémère*'s sounds and visual elements are engaged in constant transformation. They all come into being, linger and pass away in keeping with *Ephémère*'s emphasis on mortality and the ephemerality of life.

Below
CHAR DAVIES, *FOREST STREAM*, 1998. DIGITAL STILL IMAGE CAPTURED DURING IMMERSIVE PERFORMANCE OF THE VIRTUAL ENVIRONMENT *EPHÉMÈRE*

When exhibited as an installation, *Ephémère* consists not only of a private chamber for immersion, but also a screen whereby the silhouette of the participant's body can be seen by an audience. This installation design is intended to highlight the significant role that embodiment plays in the subjective experience of virtual space.

MY WORK EMBODIES THE HIDDEN POETRY OF THE ORDINARY, MAKING VISIBLE WHAT PREVIOUSLY WAS HIDDEN. *THE SECRETS OF THE MAGDALEN LAUNDRIES* EXPLORES THE THEME OF IMAGINATION IN THE INNER LIFE. DREAMING, REVERIE AND FANTASY ARE WAYS OF BEING THAT MAKE THE REALITY OF CIRCUMSTANCE MORE TOLERABLE.
DIANE FENSTER

Opposite
DIANE FENSTER, *THE SECRETS OF THE MAGDALEN LAUNDRIES* (DETAIL), 2000. PHOTO INSTALLATION, DYE-SUBLIMATION DIGITAL PRINTS AND 20 X 24 INCH POLAROID IMAGES TRANSFERRED ONTO BEDSHEETS

This installation, of which images form a primary component, creates a metaphoric laundry environment that documents Irish women who were incarcerated in laundry prisons. Consisting of fifteen bed sheets that hang into antique washtubs, the imagery proposes the idea that a retreat into inner fantasy was one of the ways in which the women survived their ordeal. The gallery is also permeated with sound recordings of women speaking and whispering in Gaelic.

Right
MASAKI FUJIHATA, *BEYOND PAGES*, 1995–99. MULTI-MEDIA INSTALLATION, 4 X 5 M (13 X 16½ FT)

Beyond Pages takes the participant on an exploration that causes him or her to rethink the nature of the book. Upon sitting down at a desk, one sees a leather-bound volume projected onto a screen and a light pen masquerading as a pencil. By moving through the pages, the participant is taken on a wonderful journey: 3D elements move across the surface of the 'paper', their movement coupled with acoustic signals, lights switch on and video doors open. In this work Masaki Fujihata calls into question the idea of the book as an interface.

PURBECK LIGHT YEARS IS A MIXTURE OF OLD AND NEW – HYBRID TECHNIQUES THAT COMBINE CHARACTERISTICS OF COMPUTER ANIMATION , PAINTING AND DRAWING AND IMMERSIVE VIRTUAL REALITY. INSIDE THIS VIRTUAL SPACE IS A WHOLE WORLD REIMAGINED, A TOPOGRAPHICAL LANDSCAPE OF CORFE CASTLE MODELLED IN THREE DIMENSIONS, SILENT AND SECRET, A PLACE OF ACCUMULATED HISTORY. THE GRAPHICS HELP CAPTURE THE IMAGINATION BY CREATING A SUBTLE AND AMBIGUOUS WORLD WHERE THE ATMOSPHERE IS LUMINOUS AND THE SPACE THREE-DIMENSIONAL. THE COLOUR WE SEE REPRESENTS SCATTERING, REFRACTION AND DIFFRACTION OF SUNLIGHT BY PARTICLES IN THE ATMOSPHERE. WEATHER SYSTEMS COME AND GO, NIGHT FOLLOWS DAY AND SEASONS CHANGE IN REAL TIME.
JEREMY GARDINER

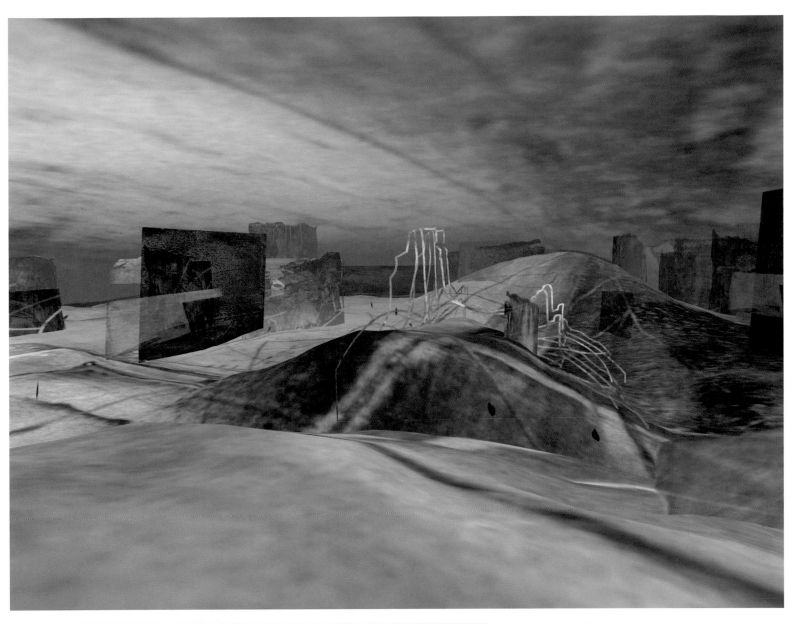

Opposite and above
**JEREMY GARDINER, *SPRING* AND *WINTER –
PURBECK LIGHT YEARS*, 2003. DIGITAL
FRAME CAPTURED FROM 3D INTERACTIVE
VIRTUAL ENVIRONMENT**
Left
**JEREMY GARDINER, *PURBECK LIGHT YEARS*,
2003. IMMERSIVE VIRTUAL ENVIRONMENT
WITH LARGE-SCALE INTERACTIVE
PROJECTIONS**

This interactive installation blends traditional painting
and digital media. The original paintings used as
inspiration for the work are on one wall, while viewers
interact with the virtual reality piece on another.
Jeremy Gardiner collaborated with programmer
Anthony Head to create this work, which is controlled
by video game hardware and software. In 2003,
Purbeck Light Years was the first digital work to win the
Peterborough Prize.

VICTORIA VESNA, *NANO*, 2004. LARGE-SCALE INTERACTIVE PROJECT, NINE INTERCONNECTED INSTALLATIONS

Victoria Vesna's recent work includes *Nano*, a series of installations that present the world of nanoscience through a participatory aesthetic experience. In the central area of the exhibition is the large Inner Cell, where participants interact with molecular forms. Using just their shadows, they are able to manipulate large-scale projected images of carbon molecules.

HEXAGONS ARE FOUND IN MANY STRUCTURES IN NATURE, INCLUDING BEEHIVES AND THE RECENTLY DISCOVERED BUCKYBALLS AND BUCKYTUBES, THE PRIMARY MOLECULES DRIVING NANOTECHNOLOGY. MY GOAL IS TO MAKE FAR-REACHING CONNECTIONS BETWEEN THE SOCIAL STRUCTURES WE UNCONSCIOUSLY BUILD AND THE ONES THAT ARE INHERENTLY THE BUILDING BLOCKS OF NATURE.
VICTORIA VESNA

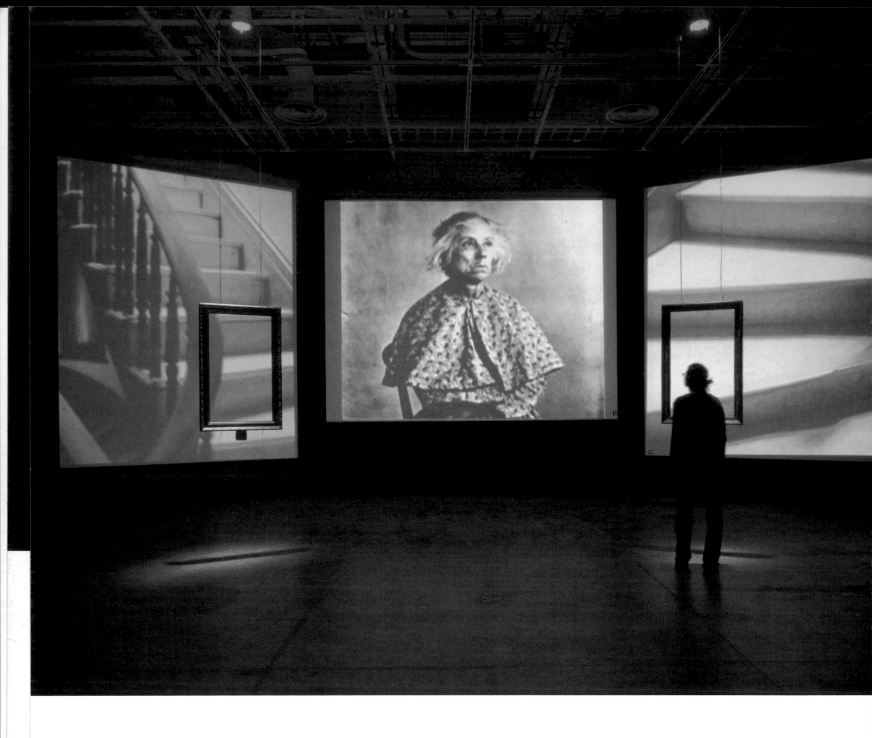

FRAMES ALLOWS THE USER TO AFFECT THE STORY BY POINTING AT THE SCREEN AND THUS TRANSFORMING AN ACTRESS INTO A 19TH-CENTURY MADWOMAN. THIS TRANSFORMATION IS THE TIMELINE OF THE PIECE, WHILE THE NARRATIVE IS IN THE COMPLEXITIES OF THE RELATIONSHIP OF PHOTOGRAPHER TO SUBJECT, AND PHOTOGRAPHER TO VIEWER. THIS IS A HIGHLY NON-LINEAR NARRATIVE STRUCTURE, AND ONE THAT CAN ONLY BE FULLY EXPRESSED IN A NON-LINEAR MEDIUM.
GRAHAME WEINBREN

Opposite
**GRAHAME WEINBREN,
FRAMES, 1999. 3-CHANNEL,
2-USER INTERACTIVE CINEMA
INSTALLATION, COMPUTER,
LASER-DISC PLAYERS,
PERIPHERAL EQUIPMENT,
VARIABLE DIMENSIONS**
Empty frames are suspended in
front of projected photographs of
mental patients taken in the 1800s
and a video of actors dressed
as patients. As the viewer points
through the frame, an interaction
is triggered between the images
and the video, the actor being
transformed into a patient.

Below right
**NOAH WARDRIP-FRUIN,
SASCHA BECKER, JOSH
CARROLL, ROBERT COOVER,
ANDREW MCCLAIN AND
SHAWN GREENLEE, *SCREEN*,
2003–05. VIRTUAL REALITY
CAVE, BODY TRACKING,
APPROX. 2.4 X 2.4 X 2.4 M
(8 X 8 X 8 FT)**
In this work, the viewer is
surrounded by a plethora of
words, text, type fragments and
spatialized sound. This flow of
text is intended to create a type
of stream-of-consciousness, as
different associations are ignited
by the visuals.

***SCREEN* BEGINS AS A READING AND LISTENING EXPERIENCE. IT COMBINES FAMILIAR GAME MECHANICS WITH VIRTUAL REALITY TECHNOLOGY TO CREATE AN EXPERIENCE OF BODILY INTERACTION WITH TEXT. MEMORY TEXTS APPEAR ON THE WALLS, SURROUNDING THE READER. THEN WORDS BEGIN TO COME LOOSE. THE READER FINDS HE OR SHE CAN KNOCK THEM BACK WITH A HAND, AND THE EXPERIENCE BECOMES A KIND OF PLAY. AT THE SAME TIME, THE LANGUAGE OF THE TEXT, TOGETHER WITH THE UNCANNY EXPERIENCE OF TOUCHING WORDS, CREATES AN EXPERIENCE THAT DOESN'T SETTLE EASILY INTO THE USUAL WAYS OF THINKING ABOUT GAMEPLAY OR VIRTUAL REALITY. WORDS PEEL FASTER AND FASTER, STRUCK WORDS DON'T ALWAYS RETURN TO WHERE THEY CAME FROM, AND WORDS WITH NOWHERE TO GO CAN BREAK APART. EVENTUALLY, WHEN TOO MANY ARE OFF THE WALL, THE REST PEEL LOOSE, SWIRL AROUND THE READER, AND COLLAPSE.**
NOAH WARDRIP-FRUIN

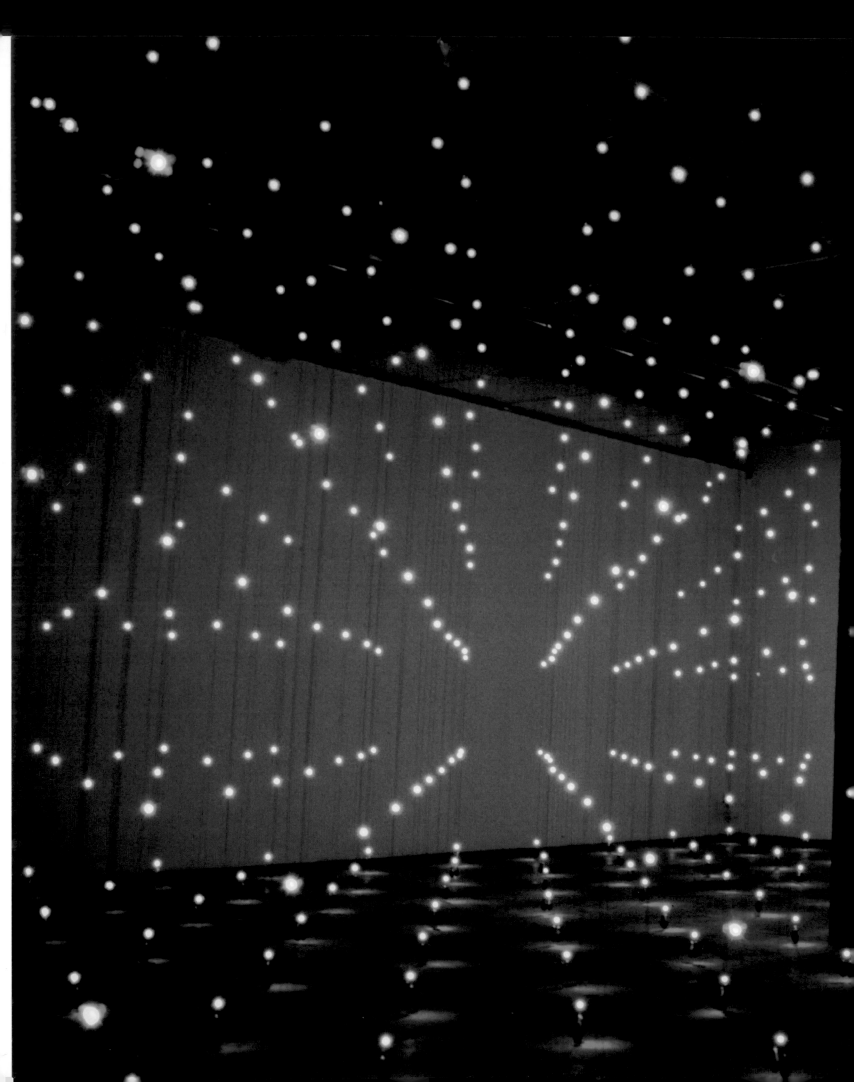

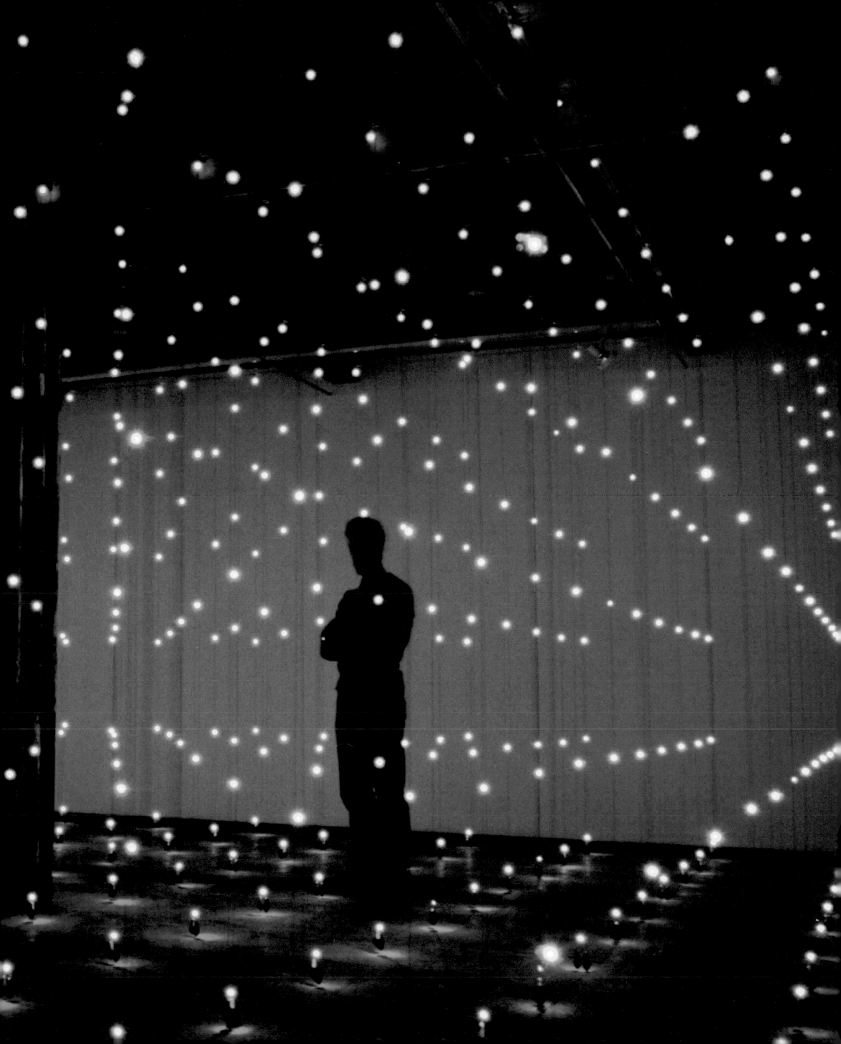

PERFORMANCE, MUSIC AND SOUND ART

While installation art and virtual reality refer primarily to artistic environments, it is the individual artist who is at the centre of performance, music and sound art. What we now call performance art emerged from the early 20th-century movements of Futurism, Dada and Surrealism, whose members often hosted provocative events that prompted audiences to reconsider their ideas about art. Among the many Futurist manifestos that were adapted for stage performance was Luigi Russolo's *Art of Noises*, which asserted that machine sounds were a viable form of music. The Dadaists and Surrealists experimented with different forms of performance and sound art. Oskar Schlemmer, who served for a period as head of the theatre workshop at the Bauhaus, was instrumental in transforming the stage into a three-dimensional art space, thus integrating the principle of unifying the arts using performance as the primary medium.

In America, John Cage and Merce Cunningham, a composer and choreographer respectively, were very influential figures in the world of avant-garde music performance, sound art and dance, and frequent collaborators. Cage approached environmental sound as the building blocks of music composition and likened his 'sound library' to a musical instrument. Cunningham sought new experimental approaches to dance and performance. Throughout the 1950s and 1960s, similar artistic sensibilities found their expression in gallery events and happenings, trends that led to the establishment of Experiments in Art and Technology (EAT) in

1966. Founded by engineers Billy Klüver and Fred Waldhauer and artists Robert Rauschenberg and Robert Whitman, EAT was a benchmark for encouraging collaboration among artists and scientists, and eventually became an international organization that included thousands of members. Composer Pauline Oliveros began developing a system in the mid-1960s called the Expanded Instrument System (EIS), which allows for improvizing musicians to collaborate through the use of tape loops and foot pedals, later adding digital processing devices. Oliveros's approach to music performance is based on the concept of deep listening – a more spiritual, meditative approach to experiencing music and sound art. The Fluxus artists' collective, which flourished during the 1960s and 1970s, was an international avant-garde group that championed artistic experimentation combined with social and political activism. The group included such artists as Joseph Beuys, John Cage, Charlotte Moorman, Yoko Ono and Nam June Paik, and many incorporated technology, performance, music and sound art into their work.

One important technological development that revolutionized electronic music was the synthesizer, invented by Robert Moog in 1964. Twenty years later, several synthesizer manufacturers banded together and adopted MIDI, the Musical Instrument Digital Interface, which enabled electronic instruments from different manufacturers to communicate with each other. MIDI has the ability to record the nuances of a performance through digital data rather than audio files, registering pitch, note on, note off, velocity and aftertouch. Since this data is available in a form that can easily be edited, copied and manipulated, a musician can correct mistakes, add harmony parts, change the voice of the instrument, or integrate any number of other features that expand the composer's palette. Recently, software emulation of synthesizers and inexpensive hardware have brought sophisticated sound modelling to the computer, particularly laptops, which are widely used for live performance by audio and video DJs.

Music and sound continue to play a significant role in the contemporary art world. In their search to stimulate and influence the audience/participant, artists produce immersive environments that skilfully combine audio and visual elements, as well as internet-based projects that encourage user interaction to shape sound worlds and artworks that feature sound and nothing else. From a practical point of view, advances in technology have allowed artists access to music and sound production environments; performance systems; affordable, user-friendly equipment; and off-the-shelf software, all of which have greatly increased their creative options. Once a work has been completed, technology also ensures artists wide distribution in such forms as CDs, DVDs, MP3 files and the numerous ways in which audio and video content can be streamed over the internet.

The phrase 'audio precedes video' aptly describes the sequence in which technological advances in analogue and digital equipment occurred. For example, the ability to record audio material onto tape preceded the invention of videotape. Since the computing power needed to handle audio data is considerably less than that required by video, the conversion of

audio production to an all-digital environment occurred relatively quickly, and although some recording studios still use analogue equipment, the vast majority have converted to digital methods of production. In 1980 the Compact Disk (CD) 'Red Book' standard was established. It is based on a sample rate of 44.1 kHz and a bit depth of 16 – the level at which the human ear does not detect any digital artifacts. While current recording systems have gone far beyond this standard, it did mark the point at which this technology matured.

The invention of the MP3 format was a further milestone in the audio revolution. This data compression system, famous for its ability to produce digital music files that can be easily downloaded, was very quickly adopted by networked communities, independent sounds artists and musicians for the purposes of file sharing and data exchange. The Apple iPod and its Podcasts are examples of commercial technology that offer distribution of music and sound art. Multi-channel sound is an emerging trend in music, performance and sound art. Fifty years ago audio recording moved from single-channel, monophonic sound to stereo. Now that DVD is one of the fastest-growing consumer technologies, interest in surround-sound and multi-channel sound art has increased. DVD-Audio technology brings studio-quality sound not only to home entertainment systems, but also to galleries and museums.

The practical application of digital sound in performance, music and sound art
The creative technologies available to performance, music and sound artists have changed dramatically in the past few decades. Whereas multi-track recording previously required very specialized, costly equipment, current software is relatively easy to use, affordable, and can run on most personal computers. The primary component of a professional digital music recording system is a computer with software such as Digidesign Pro Tools, which offers high-quality, multi-channel recording, as well as MIDI options and integration with video. In order to benefit from multiple channels of input and output, higher-level systems use an additional audio card and external hardware. A wide variety of software plug-ins for added capabilities and sound processing effects is also available. Other popular software applications include Symbolic Sound Corporation's Kyma X, Propellerhead Software Reason, Steinberg Cubase and Apple Logic Pro.

Increasingly, performance artists are incorporating sensors and other devices into their repertoire. These tools enable the control of different machines and media during a performance in a sophisticated fashion, such as sensors worn on the body of the performer that control sound and visuals. Different locations on the stage can be designated so that floor tiles, for instance, trigger changes in lighting or video sequences. This technology, such as the I-CubeX MIDI interface, allows the environment to be responsive or permits the performer to control the responses – in some cases both. Other artists configure their interface and sensors through software environments such as Cycling '74 Max/MSP. DJs prefer to work with laptop computers that function as live performance systems with audio and video

programmes that they can manipulate real-time. Today's digital artists and musicians have indeed benefited from advances in technology, and more importantly are making invaluable contributions to the evolution of digital and contemporary art.

The practitioners
The artists mentioned here come from a broad spectrum of backgrounds. While some have entered via careers in music and art, others started by writing their own custom software. The works that follow reflect different aspects of these disciplines: software-mediated performance, multi-media theatre and performance, visual music, networked performance and collaborative sound art. David Rokeby's *Very Nervous System* (p. 126) is a landmark piece in interactive music, for which he wrote custom software and configured specialized hardware. Stephen Vitiello (pp. 140–41) is a sound artist who bases his work on 'natural' sounds, both urban and rural. Ben Neill invented the 'mutantrumpet' (p. 128), an instrument that not only plays in the traditional way, but also sends MIDI instructions that modify the visual backdrop. Joan La Barbara (p. 133) and Golan Levin create collaborative, real-time performances with their art, and Levin came to work in this field though his background as a software artist (pp. 172–73). Beryl Korot and Steve Reich collaborated on *Three Tales* (p. 127) to create a work of multi-media musical theatre. Emerging artists Leesa and Nicole Abahuni, known as the 'Turbo Twins', bring robotic technology to performance through an interactive experience (p. 134).

The widespread availability of recording software has generated an increased interest among artists to create performance, music and sound artworks. The diversity of venues that now support these artistic genres – from museums, galleries, nightclubs and theatres to distribution via the internet – offers a multitude of choices to audiences.

I CREATED *VERY NERVOUS SYSTEM* FOR MANY REASONS, BUT PERHAPS THE MOST PERVASIVE REASON WAS A SIMPLE IMPULSE TOWARDS CONTRARINESS. THE INTERFACE IS UNUSUAL BECAUSE IT IS INVISIBLE AND VERY DIFFUSE, OCCUPYING A LARGE VOLUME OF SPACE, WHEREAS MOST INTERFACES ARE FOCUSED AND DEFINITE. THE INTERFACE BECOMES A ZONE OF EXPERIENCE, OF MULTI-DIMENSIONAL ENCOUNTER. THE LANGUAGE OF ENCOUNTER IS INITIALLY UNCLEAR, BUT EVOLVES AS ONE EXPLORES AND EXPERIENCES. THE INSTALLATION COULD BE DESCRIBED AS A SORT OF INSTRUMENT THAT YOU PLAY WITH YOUR BODY, BUT THAT IMPLIES A LEVEL OF CONTROL THAT I AM NOT PARTICULARLY INTERESTED IN. I AM INTERESTED IN CREATING A COMPLEX AND RESONANT RELATIONSHIP BETWEEN THE INTERACTOR AND THE SYSTEM.
DAVID ROKEBY

Opposite
**DAVID ROKEBY, *VERY NERVOUS SYSTEM*, 1986–91.
COMPUTER, SYNTHESIZER, CAMERA, CUSTOM SOFTWARE,
AMPLIFIER AND SPEAKERS, VARIABLE DIMENSIONS**
Very Nervous System relied on subtle movements of the body to create
sounds and music. Its innovative interface, which linked video, motion-
tracking software, music and movement, made it a benchmark work of
interactive art and is still used by composers, choreographers, musicians
and artists.

Below
**BERYL KOROT AND STEVE REICH, *ACT 1: HINDENBURG*
AND *ACT 2: BIKINI*, FROM *THREE TALES*, 2002.
DOCUMENTARY DIGITAL VIDEO OPERA**
Three Tales is a work of music theatre that uses events from the last century
to explore the implications of developing technology. *Act 1: Hindenburg*
recounts the story of the infamous zeppelin, while *Act 2: Bikini* focuses on
the atomic bomb testing undertaken at the Bikini atoll and the relocation
of its people. *Act 3: Dolly* (not shown) comments on the 1997 cloning of
an adult sheep in Scotland, as well as on robots and cyborgs. In addition
to musicians and singers, the theatrical setting includes video projections
of a digitally created mélange of film and video footage, photographic
stills and text. Beryl Korot, a pioneer in multi-channel video art,
approached the project as a way of bringing video art into a theatrical
context. Steve Reich is one of the most respected contemporary
composers, and innovations in composition, rhythm, orchestration and
the use of speech and sound manipulation are part of his ever-evolving
creative repertoire.

I BEGAN WORKING WITH COMPUTERS AS COMPOSITIONAL AND PERFORMANCE TOOLS IN THE LATE 1980s AND HAVE BEEN IMMERSED IN THE DIGITAL ARTS EVER SINCE. IN ADDITION TO THE EXCITEMENT OF WORKING IN SUCH A RAPIDLY-EVOLVING FORM, DIGITAL ART IS MAKING AN IMPORTANT AESTHETIC CONTRIBUTION THROUGH ITS BREAKING DOWN OF MANY PREVIOUSLY IMPENETRABLE BARRIERS BETWEEN GENRES, DISCIPLINES, ETC. THE EVOLUTION OF NEW INTERACTIVE DIGITAL VIDEO TECHNOLOGIES HAS MADE IT POSSIBLE FOR MY IDEA OF INTEGRATING SOUND AND VISION TO BE REALIZED ON A MUCH MORE ADVANCED LEVEL.
BEN NEILL

BEN NEILL, *MUTANTRUMPET*, 1990. INTERACTIVE CONTROLLER
Mutantrumpet is a composite electro-acoustic instrument. Initially created in 1984, the original subsequently underwent several variations. Based on a traditional trumpet and enhanced with MIDI and video controls, the *Mutantrumpet* represents a new hybrid instrument for performance.

BEN NEILL AND BILL JONES, *AUTOMOTIVE TOUR*, 2002. MUTANTRUMPET, MIDI-CONTROLLED VIDEO PERFORMANCE
This live performance at the House of Blues in Chicago featured composer and performer Ben Neill on his *Mutantrumpet* and Bill Jones controlling a digital video backdrop. The choice of music – 21st-century jazz – matches the improvizational nature of the audiovisual performance. The video for *Automotive* was created from remixed advertisements for Volkswagen cars, for which Neill had composed the music.

Left
CARSTEN NICOLAI, PERFORMANCE IN MONTREAL, 2001
In addition to presenting his work in galleries and museums, Carsten Nicolai also performs his electronic music and sound on stage, both as a solo artist and collaboratively.

Below
CARSTEN NICOLAI IN COLLABORATION WITH MARKO PELIJHAN, *POLAR*, 2000. INTERACTIVE MULTI-MEDIA INSTALLATION
Paired participants enter the installation with a 'POL' interface device (developed for this project) and collect data (images, sounds and temperature readings) for a set amount of time. The information from the POL is then analysed and converted into keywords that appear on monitors. A keyword is selected and a specially developed search system collects information from various databases and websites on the internet.

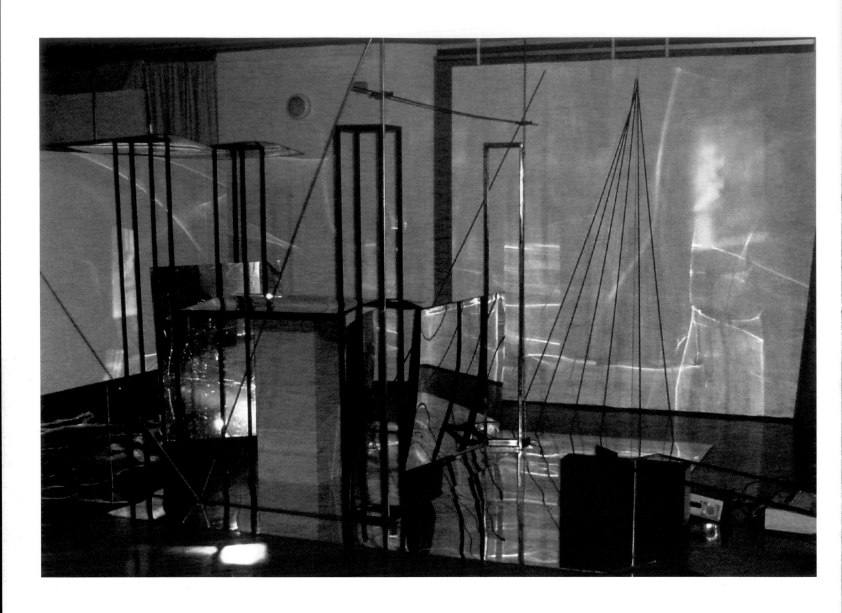

TO DEFINE A COMPLEX SYSTEM THAT GENERATES SOUNDS OR IMAGES, AND THEN MODULATE IT ... COMBINE IT WITH OTHER ELEMENTS OR USE IT AS A NEW STARTING POINT.... THE COMPUTER IS A PERFECT PARTNER: IT IS TIRELESS, SURPRISING, FLEXIBLE.
JUAN ANTONIO LLEÓ

Opposite
JUAN ANTONIO LLEÓ, *TORRE DE ESPEJOS (TOWER OF MIRRORS)*, 2003. INTERACTIVE INSTALLATION, VARIABLE DIMENSIONS
Juan Antonio Lleó's installation combines sculpture, video and music. Developed in collaboration with Antonio Alvarado, *Torre de Espejos* is composed of everyday objects, including a dozen plastic mirrors, which are illuminated by a video projector and several spotlights. Upon entering the installation, the viewer/participant finds his or her response to the music projected onto a screen and combined with video footage of a virtual reality environment.

Below
JUAN ANTONIO LLEÓ, *MIDIVERSO*, 1994–2002. INTERACTIVE INSTALLATION, VARIABLE DIMENSIONS
Designed to be experienced by large groups of people, this work consists of a large Plexiglas hemisphere equipped with thirty-two velocity-sensitive MIDI buttons. Each button triggers a different noise, and viewers can influence the sound by pressing the buttons at different speeds.

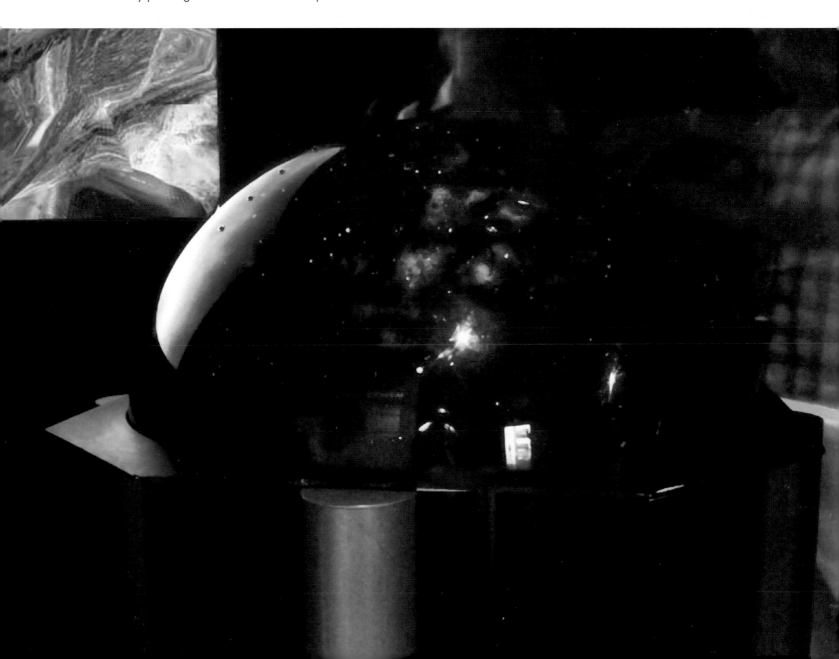

THE INTRODUCTION OF A NEW MEDIUM INVARIABLY CHANGES HOW ART HAS BEEN EVALUATED. WE ARE DOING JUST THAT RIGHT NOW. EVENTUALLY, THE ELEMENTS WE HAVE ADDED TO THE CONVERSATION BECOME THE 'TRADITIONAL CRITERIA', AND THEN A NEW MEDIUM COMES ALONG THAT ADDS TO THE CONVERSATION. IT ALWAYS TAKES TIME FOR THE NEW TO BE A PART OF THE OLD. I'M JUST THRILLED TO BE AROUND AND WORKING NOW, AND NOT FIFTY YEARS FROM NOW, SO I'M PART OF THE EARLY CONVERSATION.
JOHN KLIMA

JOHN KLIMA, *GLASBEAD*, 1999. SOFTWARE

Glasbead has a multi-user musical interface and can exist as an installation or as net art. Users assign sounds to the 'flower' parts of the spherical, bouquet-like structure. The interactivity involves spinning the entire structure with a 'click and drag' motion or individually moving the elements of the interface to strike the 'flowers' and trigger various sounds. *Glasbead* can be played by as many as twenty online participants simultaneously, enabling them to share in the creation of complex soundscapes. John Klima named the project after Hermann Hesse's novel *The Glass Bead Game*, which describes a symbolic system in which art, music, sculpture, literature and other creative art forms are deconstructed into different combinations of glass beads.

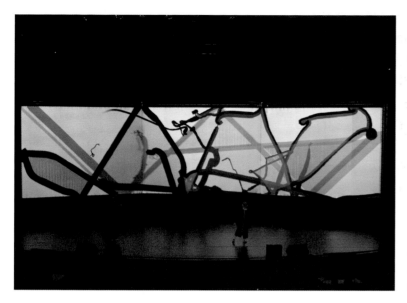

Above left
**JOAN LA BARBARA WITH GOLAN LEVIN, ZACH LIEBERMAN
AND JAAP BLONK, *MESSA DI VOCE*, 2003. PERFORMANCE AT
ARS ELECTRONICA, LINZ, AUSTRIA**

Above right
**JOAN LA BARBARA WITH GOLAN LEVIN, ZACH LIEBERMAN
AND JAAP BLONK, *MESSA DI VOCE*, 2003. PERFORMANCE AT
THE ULTRASOUND FESTIVAL, HUDDERSFIELD, ENGLAND**
Joan La Barbara is a composer, performer and sound artist who explores
the possibilities of the human voice in a series of ground-breaking works
for voices, instruments and interactive technology. Her unique vocabulary
of vocal techniques includes circular singing, ululation and glottal clicks.

***MESSA DI VOCE* IS CONCERNED WITH THE POETIC IMPLICATIONS OF MAKING THE
HUMAN VOICE VISIBLE. THE CORE TECHNOLOGY THAT MAKES THIS POSSIBLE IS
A CUSTOM SOFTWARE SYSTEM THAT INTEGRATES REAL-TIME COMPUTER VISION
AND SPEECH ANALYSIS ALGORITHMS. A COMPUTER USES A VIDEO CAMERA TO
TRACK THE LOCATIONS OF THE PERFORMERS' HEADS AND ANALYSES THE AUDIO
SIGNALS COMING FROM THEIR MICROPHONES. IN RESPONSE, THE COMPUTER
DISPLAYS VARIOUS KINDS OF VISUALIZATIONS ON A SCREEN BEHIND THE
PERFORMERS. IN SOME OF THE VISUALIZATIONS, GRAPHIC ELEMENTS REPRESENT
VOCAL SOUNDS AND ALSO SERVE AS A PLAYABLE INTERACTIVE INTERFACE BY
WHICH PERFORMERS CAN RETRIGGER AND MANIPULATE THE SOUNDS.**
JOAN LA BARBARA, GOLAN LEVIN, ZACH LIEBERMAN AND JAAP BLONK

THE INVESTIGATION OF HOW THE SENSES ARE PERCEIVED AND THE EXPLORATION OF THE INTERRELATIONSHIPS BETWEEN THE VISUAL, AURAL AND THE TACTILE ARE THE ESSENCE OF OUR CURIOSITY. WE ARE COMMITTED TO EXAMINING POTENTIAL NETWORKS AND CREATING NEW FORMS OF PERCEPTION. ULTIMATELY, WE WISH OUR WORK TO CREATE NEW RELATIONSHIPS IN THE TERRITORY BETWEEN EXISTING AND NEW SENSORY SYSTEMS. THE ACTIVE FORGING OF TACTILE, AURAL AND VISUAL PERCEPTION BETWEEN HUMANS, AND IN COLLABORATION WITH TECHNOLOGY, ASKS QUESTIONS WHICH CAN YIELD WAYS OF BETTER UNDERSTANDING, SEEING AND HEARING NATURAL ORDER.
LEESA AND NICOLE ABAHUNI

LEESA AND NICOLE ABAHUNI, *CAPACITANCE*, 2003. PERFORMANCE AND INTERACTIVE INSTALLATION. INFRARED ROBOT, MARKER PENS, PLEXIGLAS, VINYL, CUSTOM CIRCUITRY, SPEAKERS, 182.9 X 121.9 X 182.9 CM (6 X 4 X 6 FT)
The 'performer' in this work was in fact a robot that received instructions on what to draw from participants' physical interactions with low-voltage circuits. The goal of *Capacitance* was to foster potential connections between human and machine.

LEESA AND NICOLE ABAHUNI, *CHAOTIC ROBOTIC SYNESTHESIA*, 2000. PERFORMANCE. 2 INFRARED ROBOTS, MICROCONTROLLED STAGE, COLOURED LIGHTS, 4 X 4 M (13 X 13 FT)
This performance, which was inspired by the theories of psychologist Jean Dauven, explored the concept of synaesthesia – a neural condition in which the stimulation of one sense, such as hearing, produces an effect in another of the senses, such as sight, so that synaesthetes can 'see' music or 'hear' colours. Several participants – two animators, seven musicians and two robots – created and interacted with sound and coloured lights on a stage linked to microcontrollers.

**RAIN ANNE ASHFORD, *DUSTHARPS*, 2000.
INTERACTIVE ARTWORK**
This interactive musical artwork unfolds as viewers
move a mouse over the graphics, creating different
sounds and animations. Rain Anne Ashford
encourages new interpretations of the traditional
media of drawing, painting and sound.

I'M TOTALLY DRIVEN TO CREATE THINGS. I ANNOUNCED TO MY PARENTS AGED
FOUR THAT I WAS GOING TO BE AN ARTIST. I'VE BEEN PLAYING WITH SOUND
AND VISUALS AS SEPARATE ELEMENTS EVER SINCE, ALTHOUGH MULTI-MEDIA
APPLICATIONS AVAILABLE FOR HOME COMPUTERS ENABLED ME TO FIND A WAY
OF BRINGING THESE DIFFERENT MEDIA TOGETHER, USING A PROCESS WHICH
I REALLY ENJOYED. I LOVE THE INTERNET, IT'S A GREAT MEDIUM/ENVIRONMENT
TO WORK WITH.
RAIN ANNE ASHFORD

EACH OF THE IMAGES SHOWN HERE IS ONE OF THE 1000 OR SO THAT MIGHT UNFOLD DURING ONE MINUTE OF A MUSICAL PERFORMANCE. THEY ARE GENERATED IN REAL-TIME UNDER THE CONTROL OF A PLAYER WHO IS RESPONDING TO, AND INTERACTING WITH, THE MUSICIANS. MIDI CONTROLLERS AFFECT THE COLOUR, SHAPE, SIZE, PERSISTENCE AND OTHER CHARACTERISTICS OF SIMPLE OBJECTS SUCH AS LINES, ARCS AND POLYGONS.
FRED COLLOPY

FRED COLLOPY, *PHISPIRALS* AND *WOOD & WATER*, 2004. IMAGE CAPTURES OF LIVE PERFORMANCES

Fred Collopy, a programming pioneer, develops digital software that allows visual artists to play with animated graphic images in the same way that musicians play with sounds. The first version of his Imager software was devised on the Apple II computer in 1977. His creative work investigates visual music – the unification of musical and visual elements into an integrated sensory experience.

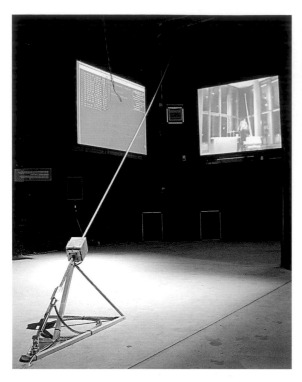

**ATAU TANAKA AND KASPER TOEPLITZ,
GLOBAL STRING, 2000. INTERACTIVE MUSIC
INSTALLATION**

Global String is a networked music installation which
is comprised of two sites, each with a steel cable
15 metres long (49 ft) that stretches diagonally from
floor to ceiling through the installation space. The
cables are connected to a real-time sound-synthesis
server sending data to the internet. Conceived as a
worldwide musical communication piece, it allows
participants from different locations to collaborate
by plucking or pulling strings. Sound data is then
streamed to each site and video projections provide
a visual connection among the users.

**MUSICIANS ARE THRILL-SEEKERS, LOOKING FOR INTENSITY AND EXCITEMENT
IN PERFORMING. WE SEEK TO TRANSMIT THIS FEELING TO THE LISTENER, TO PULL
THEM IN AND SURROUND THEM WITH THE SENSATION WE EXPERIENCE MAKING
MUSIC. IN THE END, THE VISITORS PLAYING THE INSTALLATION FORGET THE
DIGITAL BACKBONE OF THE WORK. INSTEAD, THEY ARE SURROUNDED BY THE
ORGANIC FREQUENCIES PULSING THE AIR, AND THIS IS THE SOUND OF THE
LARGER-THAN-LIFE ELECTRIC GUITAR STRING THAT THEY GRASP IN THEIR HANDS,
AND THAT DEPARTS INTO THE ETHER, INTO THE HANDS OF A REMOTE PARTNER.
ATAU TANAKA AND KASPER TOEPLITZ**

PETER TEREZAKIS, *L'AUTRE ('THE OTHER'),*
1996. SOUND INSTALLATION,
2.4 X 5.6 X 0.3 M (8 X 18 X 1 FT)
Viewers create sounds by interacting with this sculpture
within a saturated colour field. The intersections of the
steel grid contain sensors and by moving one's shadow
over them, different sounds are triggered. The work
has also been accompanied by a dance performance.

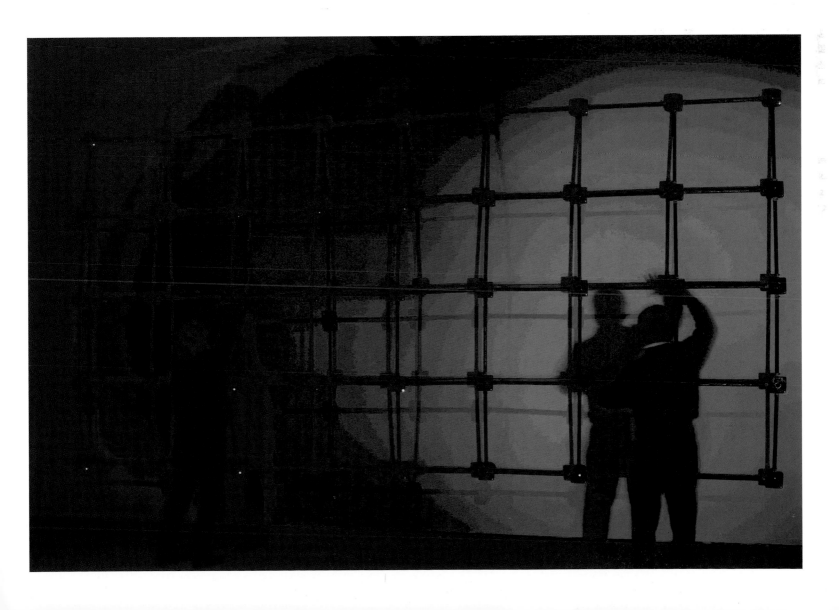

I THINK OF MYSELF MORE AS AN ANALOGUE THAN A DIGITAL ARTIST. AT THE SAME TIME, I HAVE GREATLY BENEFITED FROM THE FLEXIBILITY AND IMMEDIACY OF DIGITAL MEDIA'S EDITING, STORAGE AND PROCESSING POTENTIAL. MAYBE IT'S BETTER TO SAY I HAVE DONE MY BEST TO KEEP A HEALTHY TENSION BETWEEN ANALOGUE CIRCUITRY AND DIGITAL TOOLS.
STEPHEN VITIELLO

Left
STEPHEN VITIELLO, *WORLD TRADE CENTER RECORDINGS: WINDS AFTER HURRICANE FLOYD*, 1999. MIXED-MEDIA SOUND INSTALLATION
This installation began with two microphones taped to the inside of windows at the World Trade Center in New York. The sounds – which included passing planes and helicopters, traffic, and the noise of the building swaying in the post-hurricane wind – were recorded during Stephen Vitiello's six-month participation in the World Views Artist Residency Program. They were later played back in a darkened gallery.

Opposite
STEPHEN VITIELLO, *FROGS IN FEEDBACK*, 2002. MICROPHONE, GLITTER-BALL MOTOR, SPEAKER, DIGITAL PROCESSOR
Stephen Vitiello takes components that both record and reproduce sounds and uses them as sculptural elements to define the atmosphere of an environment. Here, the slow, mechanical rotation of a microphone over a speaker cone produces feedback of varying pitch and intensity that seems to emanate from the gallery's walls and windows.

instrumental in establishing computer programming as a new and valid method of animation – moving it from a traditional, hand-animated, team-designed narrative medium to an art form produced by an individual. Yoichiro Kawaguchi also incorporates elements of artificial life in his work (pp. 152–53). Dennis H. Miller uses programming, but in an intimate relationship with music to create his animation (pp. 154–55); Wayne Lytle takes this concept even further with his MIDI-driven musical instruments, which are the central characters in his work (pp. 156–57). A very different approach is taken by Clara Chan in *Autumn Bamboo* (opposite), in which she has chosen to retain the traditional aesthetic of Chinese painting while adding the modern dimension of animation. Toni Dove explores the concepts of alternative cinema, not only through her approach to plot and narrative, but also through the incorporation of her work into interactive environments (pp. 150–51); and Jim Campbell's methods include image-processing techniques, installation, surveillance and even the incorporation of the gallery visitor into the video artwork (pp. 16, 146).

Works that incorporate video and animation into net art, software and other digital art forms can be found in other chapters. In addition, a multitude of annual festivals held around the world offer the opportunity to view independent digital animation and video, and there are several specialized venues. Of particular note are the annual ACM SIGGRAPH conference in the United States; the Ars Electronica Centre in Linz, Austria; Zentrum für Kunst und Medientechnologie Karlsruhe (ZKM), Germany; Inter-Society for the Electronic Arts (ISEA); the New York Digital Salon; and the RESFEST travelling digital film festival.

The works that follow reflect the diversity of time-based media and have been chosen for their historical significance, the artist's unique approach, or because they constitute a landmark within the landscape of digital animation and video art.

**CLARA CHAN, *AUTUMN BAMBOO*, 2000.
COMPUTER ANIMATION**
Chinese brush painting has existed for thousands of
years and is defined by strict stylistic standards. In this
brief but beautifully contemplative work, Clara Chan
has brought the art form to life, so that the viewer
seems to move between the bamboo stems. At the last
moment, the scene is revealed as a painting on a fan,
which snaps shut. The final look was achieved through
creating procedural shaders using the Renderman
programming language and Maya software.

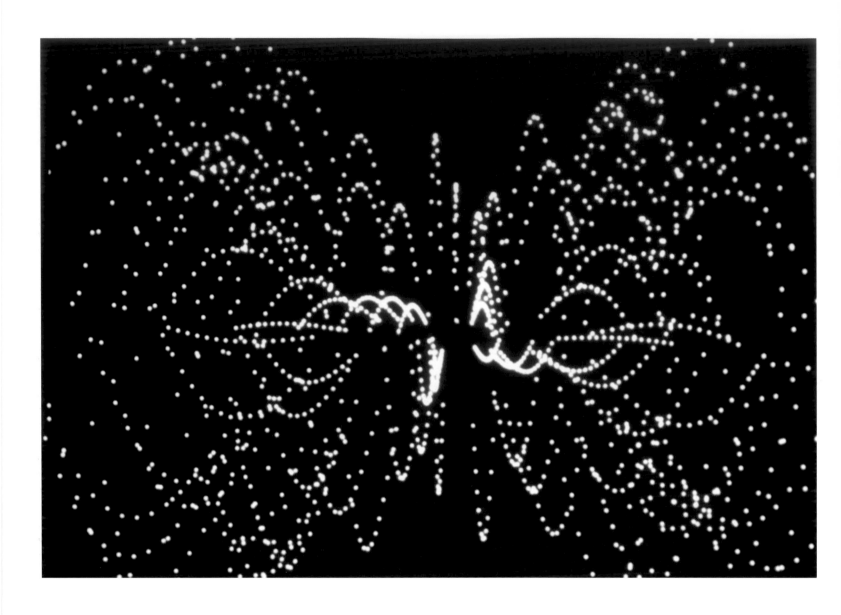

**WRITING COMPUTER CODE IS CREATING A PATTERN THAT
CREATES PATTERN. AN UNPREDICTABLE VISUAL COMPOSITION
EMERGES FROM A MATHEMATICAL STRUCTURE. I COLLABORATE
WITH AN ANIMATION-PRODUCING ROBOT WHOSE BEHAVIOUR
I DESIGN. OVER TIME THE ALGORITHMS, IMAGERY AND ARTIST
COEVOLVE.**
LARRY CUBA

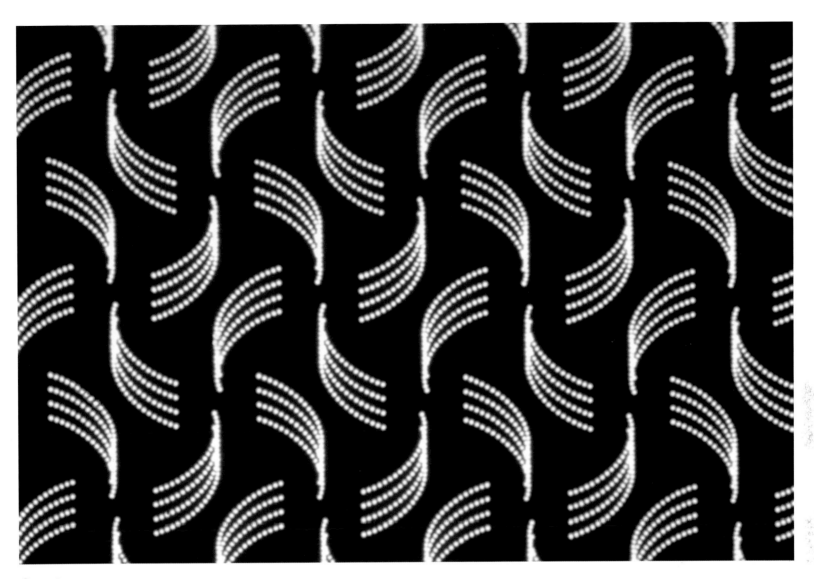

Opposite
LARRY CUBA, *3/78 (OBJECTS AND TRANSFORMATIONS)*, 1978. 16 MM FILM
Larry Cuba is widely held to be a pioneer in computer animation, having produced his first animation with the aid of computers in 1974. In *3/78 (Objects and Transformations)*, 16 abstract shapes, each made of 100 points of white light, move across a black screen in rhythmically precise, carefully choreographed patterns to the accompaniment of a Japanese flute.

Above
LARRY CUBA, *TWO SPACE*, 1979. 16 MM FILM
To create *Two Space*, Larry Cuba used a programming language called RAP to rotate, reflect and explore a number of classic forms used by Islamic artists. Since the animated patterns are once more formed of white points on a black background, their continuous movement causes the eye to see after-images in the negative space.

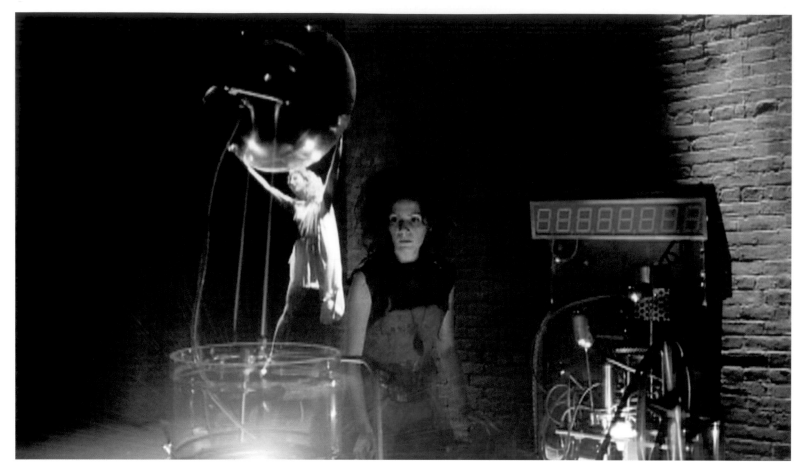

MY WORK EXISTS IN A BERMUDA TRIANGLE BETWEEN GAMES, THEATRE AND FILM. SOMETIMES I FEEL LIKE I'M MAKING BUILDINGS OUT OF MOVIES – ALLOWING VIEWERS TO NAVIGATE THE SPACE OF STORIES – OR ELSE I'M AN AUTOMATON CREATOR OR PUPPETEER – MAKING CHARACTERS THAT ARE BOTH INHABITABLE AND RESPONSIVE. I HAVE ALWAYS HAD THE DESIRE TO SPATIALIZE CINEMA – TO MAKE IT DIMENSIONAL IN A WAY THAT TUGS AGAINST THE LINEARITY OF SEQUENTIAL STORY TIME, ALLOWING FOR A MORE IMMERSIVE EXPERIENCE. MY ENGINES HELP ME TO ANALYSE AND RECONSTRUCT TIME, MEMORY AND STORY – TO KEEP IT CONSTANTLY FLUID AND UNFIXED.
TONI DOVE

Above
TONI DOVE, *SPECTROPIA CONJURES SALLY* FROM *SPECTROPIA*, 1999–2002. INTERACTIVE PERFORMANCE, MULTIPLE COMPUTERS AND CUSTOM INTERFACE.
Spectropia is a cinema-scale interactive performance event, a 'scratchable' movie performed by video DJs – improvizing performers who are playing a movie as an instrument. Projected on multiple screens and performed with the participation of audience members, *Spectropia* is meant to push the boundaries of theatrical performance using interactive video and other new technologies. The story is described as a 'supernatural thriller' by Toni Dove and takes place in the future and in the city of New York, 1931.

Opposite
TONI DOVE, *SALLY'S DRESSING ROOM* AND *SALLY'S BUBBLE DANCE*, FROM *SALLY OR THE BUBBLE BURST*, 2003. INTERACTIVE DIGITAL INSTALLATION
Sally or The Bubble Burst is a work that incorporates interactive video and storytelling, and is based on the 1930s bubble dancer Sally Rand. Viewers can speak or sing into a microphone, or use the mouse and keyboard, to experience and navigate the work. There are several ways to explore the piece, which include engaging with the responsive bubble dance, interacting with the character and accessing information about the Great Depression.

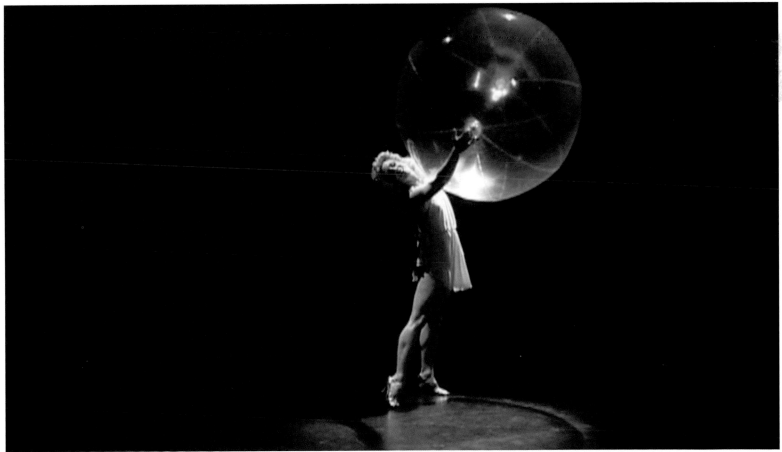

Below left
**YOICHIRO KAWAGUCHI, *NEBULAR*, 2000.
HDTV ANIMATION**
These images reflect the progression of Yoichiro
Kawaguchi's art and working methods. His more
recent work, below left and opposite, incorporates
a principle he calls 'Gemotion', which he defines
as 'growing, evolving and hereditary emotional art'.
Kawaguchi's forms have now become capable of
self-organization, artificial life, communication, self-
replication and evolution. In addition, his work has
expanded from animation to include other media,
such as performance art and interactive works.

Below right
**YOICHIRO KAWAGUCHI, *ARTIFICIAL LIFE
METROPOLIS CELL*, 1993. HDTV ANIMATION**
Yoichiro Kawaguchi's use of the Growth Rationale
Object Work Theorem (GROWTH) Model began
in 1975 and was based on the development of
a metamorphic algorithmic model. A key principle
of this model is the use of recursive forms, which are
repetitions of simple rules within complex structures.
This is clearly seen in his use of spirals and other
organically shaped curves taken from natural forms,
such as sea shells, tentacles, eddies and currents.
The end product is not intended to create a faithful
representation of reality, but rather to produce a new
bionomic pictorial space.

Opposite
**YOICHIRO KAWAGUCHI, *TOPOLON*, 2001.
HDTV ANIMATION**

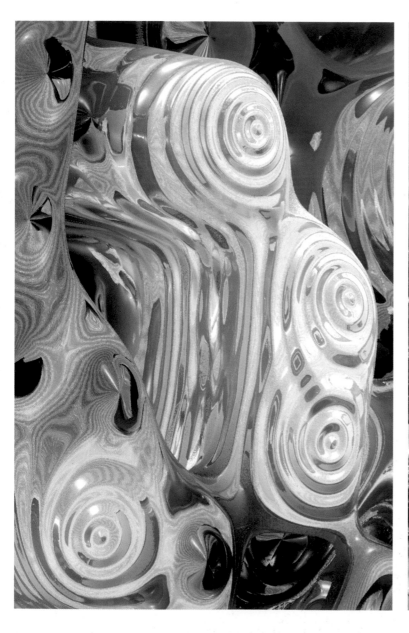

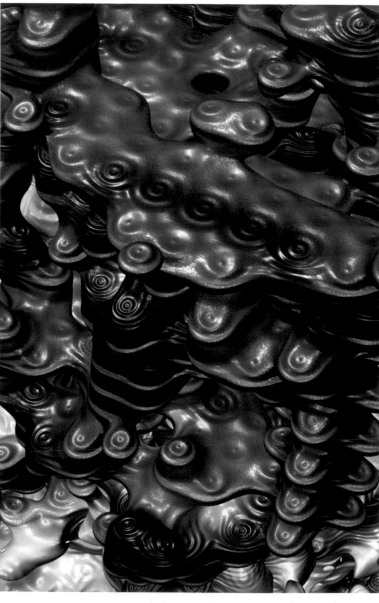

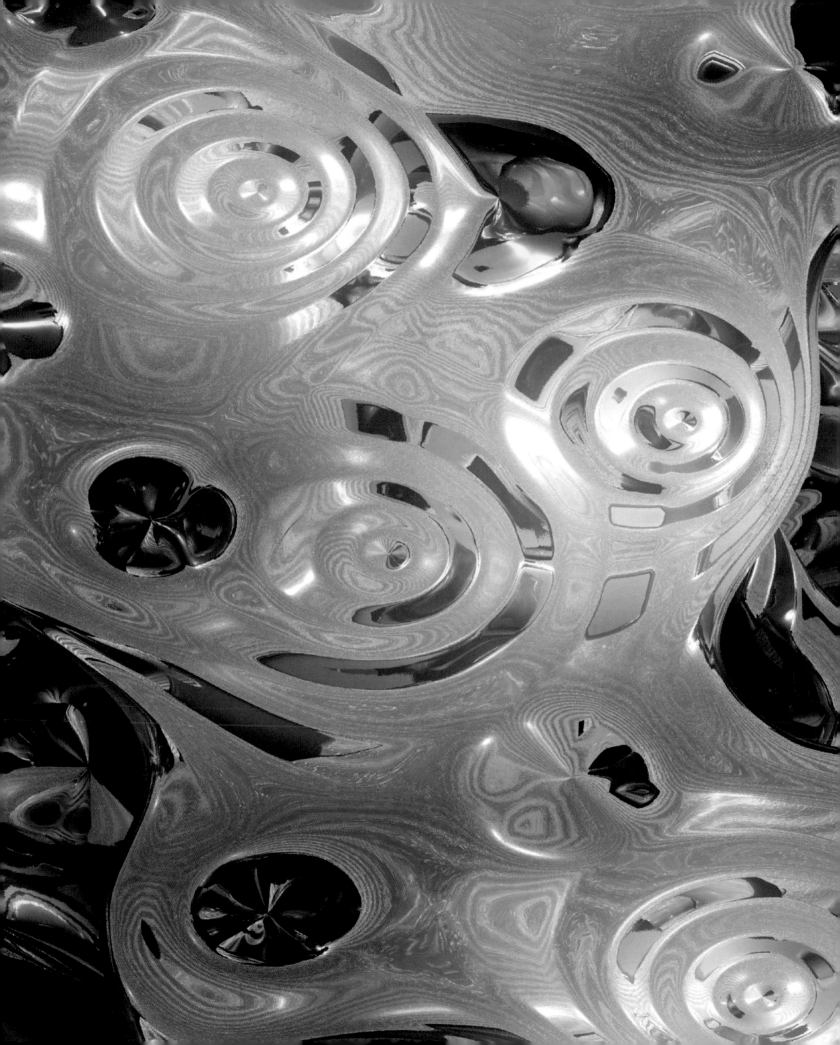

Above
DENNIS H. MILLER, *FAKTURA 2*, 2003. COMPUTER ANIMATION
Dennis H. Miller came to visual art and animation from a background
as a composer and brings elements of a musical aesthetic to his work in
the form of repetitive, rhythmic patterns of movement. The visual material
of *Faktura 2* was created with the POV-Ray (persistance of vision ray
tracer) scene description language. Its techniques include the morphing of
iso-surfaces and the application of control parameters extracted from pre-
existing sequences of bitmap files to control the motion of new, synthetic
images.

Opposite
DENNIS H. MILLER, *VIS A VIS*, 2002. COMPUTER ANIMATION
Vis a Vis combines music and imagery that share a number of governing
principles, both technical and formal. A grid-like image might be
superimposed over a swirling, amorphous background, while the
accompanying music makes use of a similar 'contrapuntal' configuration.
Continuity is achieved through a series of variations on the visual and
musical motifs that opened the piece.

UNLIKE SOME MIXED-MEDIA WORKS, WHERE THE PARAMETERS OF THE MUSIC DIRECTLY CONTROL ASPECTS OF THE PICTURE (OR VICE VERSA), I VIEW MUSIC AND ANIMATION AS TWO SEPARATE BUT EQUAL STREAMS THAT HAPPEN TO COEXIST IN THE SAME TIME FRAME. MY GOAL IS TO APPLY THE SAME PRINCIPLES OF CONTINUITY AND DEVELOPMENT TO THE VISUAL AND MUSICAL ELEMENTS; IN OTHER WORDS, TO UNIFY THE WORKS BY MAKING THEMATIC CONNECTIONS THAT ARE MORE OR LESS TRANSPARENT TO THE VIEWER.
DENNIS H. MILLER

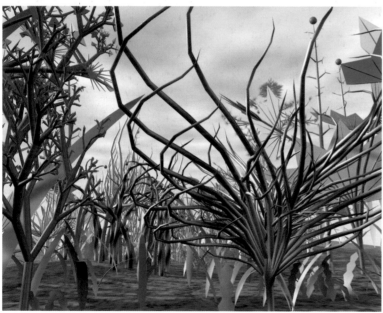

I ATTEMPTED TO UNITE SEVERAL CONCEPTS: CHAOS, COMPLEXITY, EVOLUTION, SELF-PROPAGATING ENTITIES AND THE NATURE OF LIFE ITSELF. THIS BOTANICAL FORM OF LIFE, REPRODUCING ITSELF FROM PLANET TO PLANET THROUGH SPACE, IS IN MANY WAYS ANALOGOUS TO OTHER SELF-REPLICATING SYSTEMS, INCLUDING ORGANISMS, ENTIRE SPECIES OR EVEN IDEAS. A WINDOW INTO THIS SYSTEM, REPLICATING ON A GRANDER SCALE, IS MEANT TO INCREASE AWARENESS OF SELF-PROPAGATING SYSTEMS IN GENERAL, AS WELL AS INSPIRE THOUGHTS ABOUT OUR ENTIRE PLANET.
KARL SIMS

KARL SIMS, *PANSPERMIA*, 1990. COMPUTER ANIMATION
Panspermia portrays the life cycle of an imaginary intergalactic life form.
From the opening sequence, which shows the arrival of a seed pod on
a planet's surface, we see the plants begin to grow and take adult form,
develop into a forest and finally launch more spores into space,
beginning the process anew. Karl Sims used original software to create
and animate the 3D plant structures.

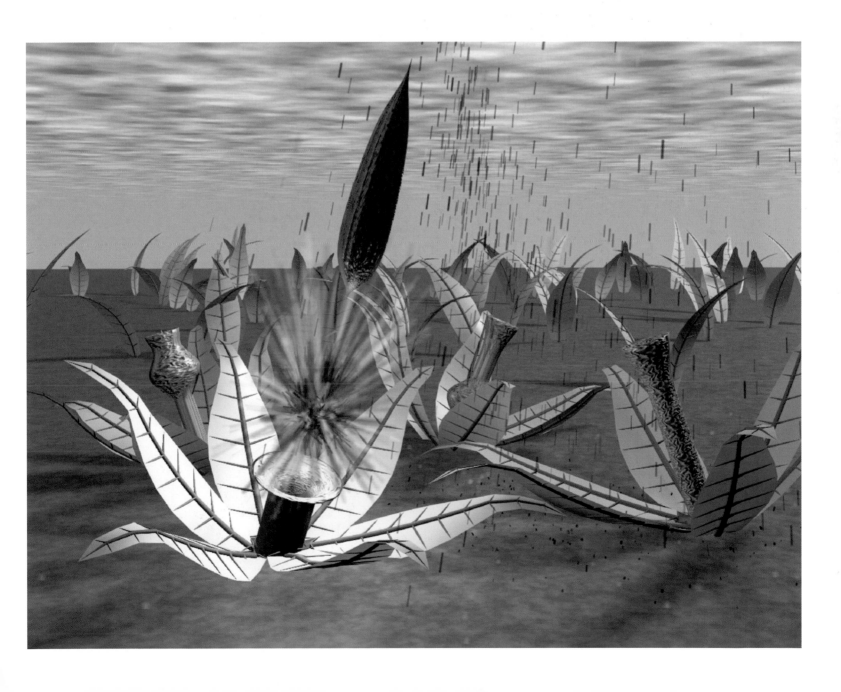

IT IS FROM NATURE THAT I DRAW MY INSPIRATION, AND NATURE IS THE VERY ELEMENT THAT DOMINATES MY WORK. I ENJOY AND SPEND TIME WATCHING THE CLOUDS OR THE GLOWING REFLECTIONS ON PLANTS; AND WHEN I WORK I LET ALL THE IMAGES I HAVE ABSORBED EMERGE THROUGH MY MEMORY.
OPY ZOUNI

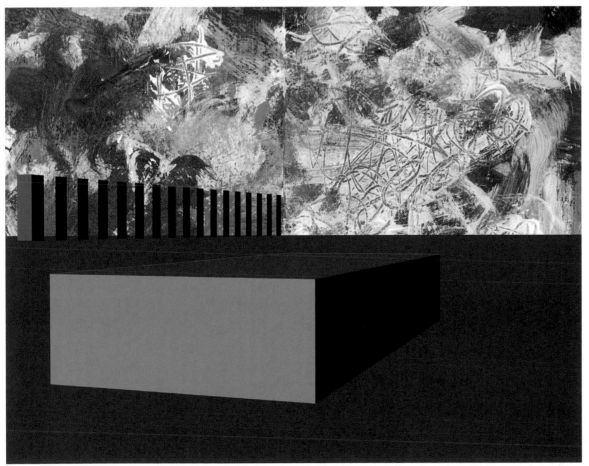

Opposite
OPY ZOUNI, *ART AND INDUSTRIAL PRODUCT*, 2004. DIGITAL VIDEO

Left
OPY ZOUNI, *LIGHT/SHADOW/ COINCIDENCES*, 1999. DIGITAL VIDEO

Below left
OPY ZOUNI, *ART AND CAR*, 2003. DIGITAL VIDEO
In her video pieces, Opy Zouni uses optical phenomena, symmetry and geometry, often observed from nature, to create a very minimal aesthetic. She cites the Bauhaus art movement as a significant influence on her work.

SOFTWARE, DATABASE AND GAME ART

While art forms such as prints, sculpture and even installation evolved from traditional media and techniques, software, database and game art came into existence only when artists started experimenting with computers. There is a fine line between where art that has a primary component of software ends and other categories begin. For example, an artist can write a software programme and then output the artwork as a print or sculpture, or include it in an interactive installation. Every type of digital art makes use of software in some form. For the purposes of this exploration, software art is defined as creative work that finds its origins in programmes written by the artist; database art relies on pre-existing, created or real-time collections of information; and game art uses commercial gaming software or incorporates elements of play and role-playing. Networked games are a hybrid between game art and net art.

Software art finds its primary expression in computer code. Artist and programmer John F. Simon, Jr., likes to refer to programming as a form of creative writing, in which the artist's 'words' exist as lines of code; others have called it the 'paint and canvas' of the digital artist. With *Every Icon* (p. 171), Simon produced an almost endless series of visual images on a 32 x 32 grid, all powered by the algorithms of computer code. While Simon's work is self-generating, Golan Levin's approach to software art in his *Audiovisual Environment Suite* (pp. 172–73) gives creative control to the user through a minimal interface that produces abstract visual images,

animations and sound in real time. Levin describes his work as an 'attempt to reclaim computation as a personal medium of expression'.

A third type of software art has been employed by Alexander R. Galloway (pp. 168, 202) and the Radical Software Group. Carnivore was originally designed as a multi-purpose surveillance tool for data networks, inspired by software the FBI used under the nickname 'Carnivore' to perform electronic wiretaps. *CarnivorePE* (p. 168) is the resultant software application that monitors all internet traffic (email, web surfing) from a specific local network and then puts this data in a form that can be creatively interpreted in any number of ways by other artists. These interpretations, called 'clients', take the form of image and sound generators, or works that utilize breath interfaces; one work by Golan Levin, *JJ*, translates the emotional meaning of words that travel over a network into facial expressions.

While software art embodies the concept of authorship of the software code, database artists take a more interpretative approach through collections of data that exist on disk, the internet, derive from other sources, or are created by the participants and viewers of the artwork itself. A major concern for artists creating database art is to filter, chart or 'map' the information, to visualize it and make it meaningful for an audience. In *Pockets Full of Memories* (pp. 175–77), George Legrady involves the audience in the creation of the database, inviting them to scan their personal possessions and then to ponder the concept of a communal archive and the way in which collective memory functions. Marek Walczak and Martin Wattenberg's *Apartment* (pp. 178–79) encourages participants to create their own database of words, which the software visualizes with an architectural blueprint.

An example of a database artwork that uses real-time stock market data from the internet is Lynn Hershman Leeson's *Synthia* (p. 167). Josh On is similarly concerned with market forces, but in a more people-oriented way: *They Rule* (p. 169) is piece of net art that allows users to trace graphically the relationships between board members of various American corporations. W. Bradford Paley (pp. 182–83) writes software that analyses works of literature and other texts and creates a visual interpretation of patterns hidden within the data. In her works *American Views: Stories of the Landscape* (p. 169) and *NYC Thought Pictures: Memories of Place*, Russet Lederman presents a non-linear collage of the American landscape as seen through the experiences and memories of diverse individuals. These works are accomplished through the development of databases that contain images, sound and text.

The creative interplay between artists and games came to public prominence in 2001 with 'Game Show', exhibited at the Massachusetts Museum of Contemporary Art. Positioned as the first major exhibition to explore how artists have incorporated game structures and themes in their work, the show was composed of four sections: Games Visitors Play, Games Artists Play, Games Artists Orchestrate and Net Games Now, which was curated by Mark Tribe and Alexander R. Galloway of Rhizome.org. This

THE BIGGEST CULTURAL RAMIFICATION I SEE IS THAT SOFTWARE IS AN ACTION MEDIUM. SOFTWARE DOES STUFF. THIS IS ENTIRELY DIFFERENT FROM LITERATURE, FILM, OR OTHER PREVIOUS MEDIA. FRIEDRICH A. KITTLER HAS SUMMARIZED THIS POINT BY WRITING THAT CODE IS THE FIRST TYPE OF LANGUAGE THAT DOES WHAT IT SAYS. I AGREE WITH HIM. SOFTWARE IS A TYPE OF MACHINE FOR CONVERTING MEANING INTO ACTION.
ALEXANDER R. GALLOWAY

ALEXANDER R. GALLOWAY AND RSG, *CARNIVORE PE*, 2001. SOFTWARE
This is the Macintosh version of the *CarnivorePE* (Personal Edition) interface, which monitors the flow of data over a specific network. The number of packets of data that are output per second can be counted and can vary. The data format can also be defined. It has a security option to allow clients from other computers to connect or prevent them from doing so. The Radical Software Group (RSG) is an international collective of various programmers and artists who write and work with experimental software. Artists who have incorporated RSG's software in their artworks include Jonah Brucker-Cohen, Vuk Cosic, Joshua Davis, Entropy8Zuper!, Golan Levin and Mark Napier.

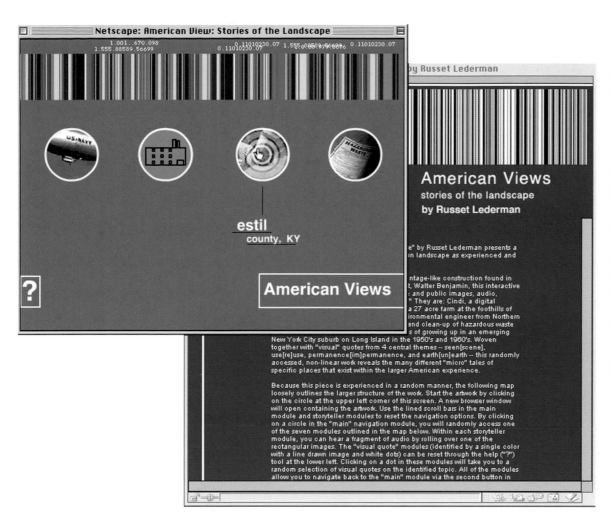

RUSSET LEDERMAN, AMERICAN VIEWS: STORIES OF THE LANDSCAPE, 2001. ONLINE ARTWORK

American Views is a series of interactive stories that was commissioned by the Smithsonian American Art Museum. The three main characters are Cindi Cusick, a digital designer from Kentucky; Adam Klein, an environmental engineer from California; and Neil Duskis, a Long Island suburbanite. Through text, audio and graphics, random portions of each character's story are presented in relation to the work's four main themes: seen[scene], permanence [im]permanence, earth[un]earth and use[re]use. A larger perspective of the American cultural landscape is gained through experiencing the stories of these characters.

JOSH ON, THEY RULE, 2001. ONLINE ARTWORK. MAP CREATED BY CHRIS MACGREGOR

Political activism has often played a very visible part in contemporary art. In *They Rule*, Josh On states his case with subtle eloquence. This online artwork lets users create graphic maps showing the links between individuals who sit on the board of directors of various prominent corporations. The resulting patterns expose some not-so-obvious connections, revealing the inner structure of corporate governance and providing a unique glimpse of what the artist refers to as the 'U.S. ruling class'. A large collection of these maps are available at www.theyrule.net.

Opposite above and below
GOLAN LEVIN, *FLOCCUS* AND *YELLOWTAIL*, 1999. INTERACTIVE SOFTWARE
Floccus and *Yellowtail* are components of the Audiovisual Environment Suite, a set of interactive software systems designed so that people can create abstract animations and synthetic sounds in real-time. In a typical installation of these works, a pedestal with a computer mouse on top is positioned in the centre of a darkened room, and a video projector displays a large image on one of the walls. The software interface is simple and intuitive, and within a short period of time users are creating a wide variety of abstract visuals and sounds. An interesting aspect of Golan Levin's work is that each person who uses the software ends up with his or her own unique visuals.

Below
GOLAN LEVIN, SCOTT GIBBONS AND GREGORY SHAKAR, *SCRIBBLE*, 2000. NEW MEDIA PERFORMANCE AT ARS ELECTRONICA, LINZ, AUSTRIA
This image shows a concert performance of *Scribble*, also produced through the Audiovisual Environment Suite. The work revives and updates a decades-old tradition of kinetic light performance, featuring tightly coupled sounds and dynamic visuals that are at times carefully scored, and at other times loosely improvized.

IN *FLOCCUS*, DUCTILE FILAMENTS DRAWN BY THE USER SWIRL AROUND A SHIFTING, IMAGINARY DRAIN CENTRED AT THE USER'S CURSOR. THESE FILAMENTS ARE TORN BY CONFLICTING IMPULSES TO SIMULTANEOUSLY PRESERVE THEIR LENGTH, YET ALSO MOVE TOWARDS OR AWAY FROM THE CURSOR. THEY FIND AN EQUILIBRIUM BY FORMING GNARLY, TANGLED MASSES.
GOLAN LEVIN

MICHAEL FIELD, *ARMIES OF THE NIGHT*, 2000.
DURST LAMBDA PRINT, 86.3 X 86.3 CM (34 X 34 IN)
Michael Field relies on the interplay between symmetrical
and chaotic systems in his mathematically generated images,
focusing on the underlying structure that can sometimes be
concealed by chaos. Colour, movement and illusion are
important elements of his work.

LIFE ITSELF – DEPENDING AS IT DOES ON THE STATISTICAL LAWS OF GENETICS AND INHERITANCE – IS MAYBE THE BEST AND MOST FAMILIAR EXPRESSION OF THE ROLE THAT RANDOMNESS PLAYS IN OUR EXISTENCE. VIEWED IN THIS LIGHT, RANDOMNESS COEXISTS WITH AND ILLUMINATES FORM AND STRUCTURE – THE OPPOSITE OF THE CONVENTIONAL VIEW THAT CHAOS IS THE ANTITHESIS OF STRUCTURE.
MICHAEL FIELD

Right and overleaf
GEORGE LEGRADY, *POCKETS FULL OF MEMORIES*, 2001. INTERACTIVE INSTALLATION

Visitors to this installation scan their personal possessions at a kiosk and the objects are then categorized according to a software algorithm written by Timo Honkela and Timo Koskenniemi. At the start of the exhibition the database is empty but grows through the public's contributions. The algorithm organizes the data throughout, to arrive at a final ordered state at the end of the exhibition. The phenomenon of proceeding from small local actions (each contribution) to a final ordered state is called 'emergence', since the order emerges over time through the local interactions generated by the algorithm each time a new object enters the database. In this sense, the system has been defined as 'self-organizing'.

***POCKETS FULL OF MEMORIES* IS AN INTERACTIVE INSTALLATION IN WHICH THE PUBLIC CONTRIBUTE AN IMAGE OF AN OBJECT IN THEIR POSSESSION TO AN ARCHIVE THAT GROWS THROUGHOUT THE EXHIBITION. THE DATA IS STORED IN A DATABASE THAT IS PROJECTED LARGE-SCALE IN THE GALLERY AND IS ACCESSIBLE ON THE INTERNET. THE KOHONEN SELF-ORGANIZING MAP ALGORITHM DETERMINES THE LOCATION OF THE OBJECTS BY POSITIONING THEM IN A TWO-DIMENSIONAL MATRIX ACCORDING TO SIMILARITIES DEFINED BY THE CONTRIBUTORS. THE AUDIENCE CAN ALSO INTERACT WITH THE DATA ONLINE TO ACCESS DESCRIPTIONS AND TO CONTRIBUTE COMMENTS.**
GEORGE LEGRADY

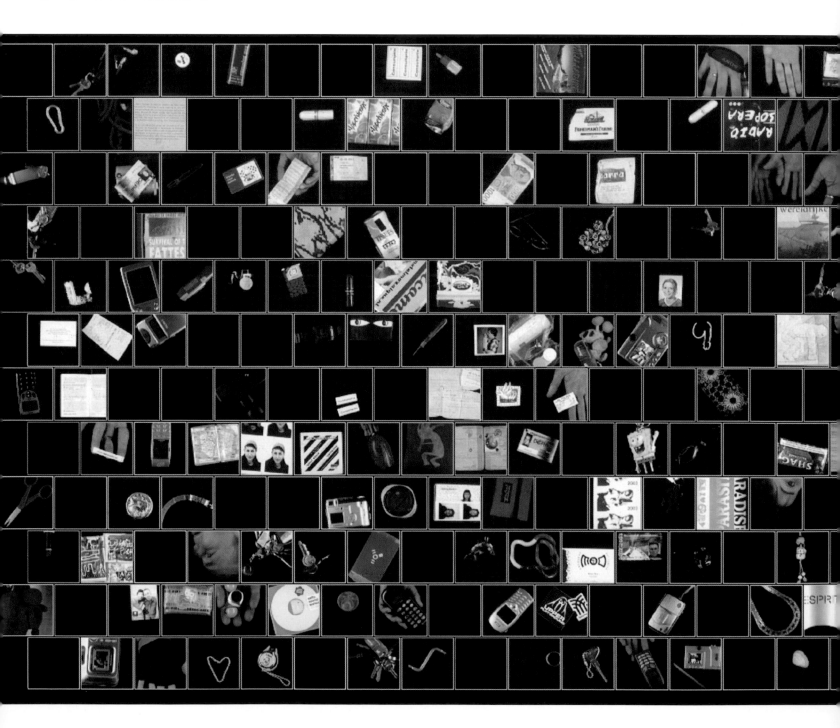

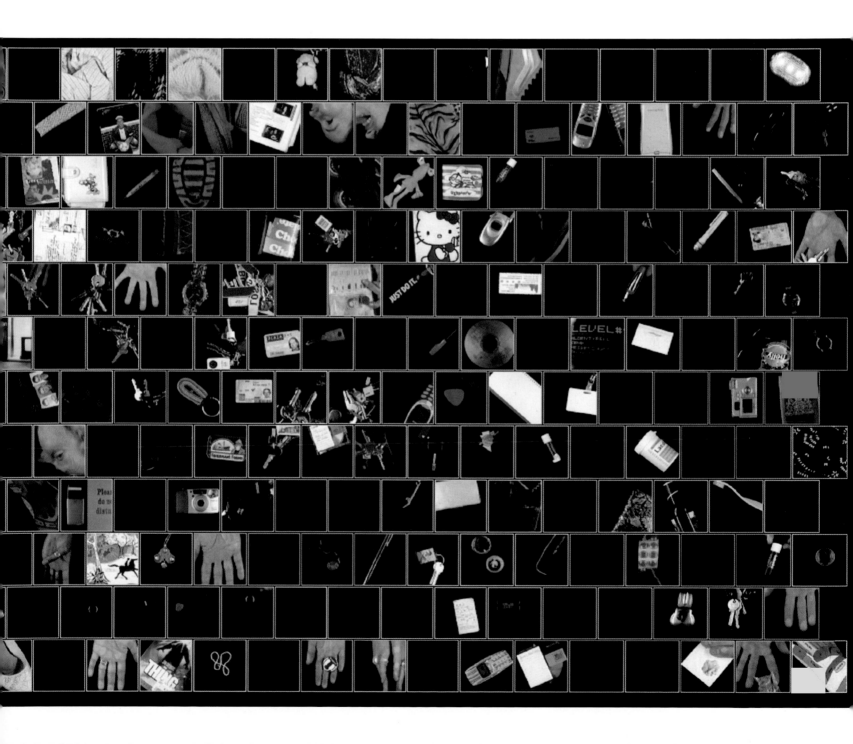

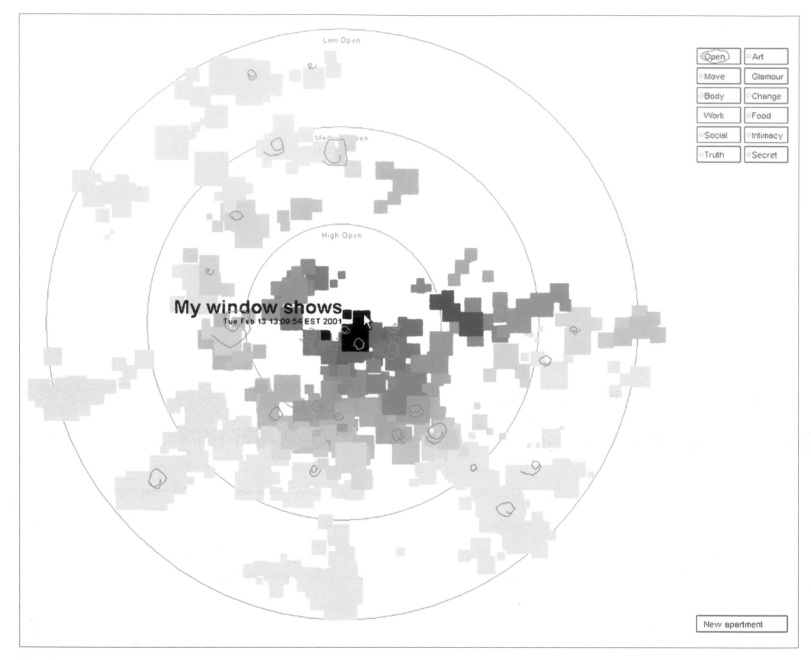

MAREK WALCZAK AND MARTIN WATTENBERG, *APARTMENT*, 2001. WEB- AND INSTALLATION-BASED SOFTWARE, VARIABLE DIMENSIONS

Apartment is an example of database art that requires visitors to the gallery or to the website to create and define the contents of the database. Conceptually, the work is similar in approach to George Legrady's *Pockets Full of Memories* (pp. 176–77); however, in this instance words replace personal items as the fundamental data. Words typed into the computer prompt the appearance of rooms or 'apartments', the architecture of which is determined by the computer's analysis. The apartments are then converted into navigable 3D environments composed of various images.

VIEWERS ARE CONFRONTED WITH A BLINKING CURSOR. AS THEY TYPE, ROOMS BEGIN TO TAKE SHAPE IN THE FORM OF A TWO-DIMENSIONAL PLAN, SIMILAR TO A BLUEPRINT. THE ARCHITECTURE IS BASED ON A SEMANTIC ANALYSIS OF THE VIEWER'S WORDS, REORGANIZED TO REFLECT THE UNDERLYING THEMES THEY EXPRESS. THE APARTMENTS ARE THEN CLUSTERED INTO BUILDINGS AND CITIES ACCORDING TO THEIR LINGUISTIC RELATIONSHIPS. IN A MNEMONIC TECHNIQUE, LONG BEFORE THE 'POST-IT' ERA, CICERO IMAGINED INSCRIBING THE THEMES OF A SPEECH ON A SUITE OF ROOMS IN A VILLA, AND THEN RECITING THAT SPEECH BY MENTALLY WALKING FROM SPACE TO SPACE. ESTABLISHING AN EQUIVALENCE BETWEEN LANGUAGE AND SPACE, *APARTMENT* CONNECTS THE WRITTEN WORD WITH DIFFERENT FORMS OF SPATIAL CONFIGURATIONS.
MARTIN WALCZAK AND MARTIN WATTENBERG

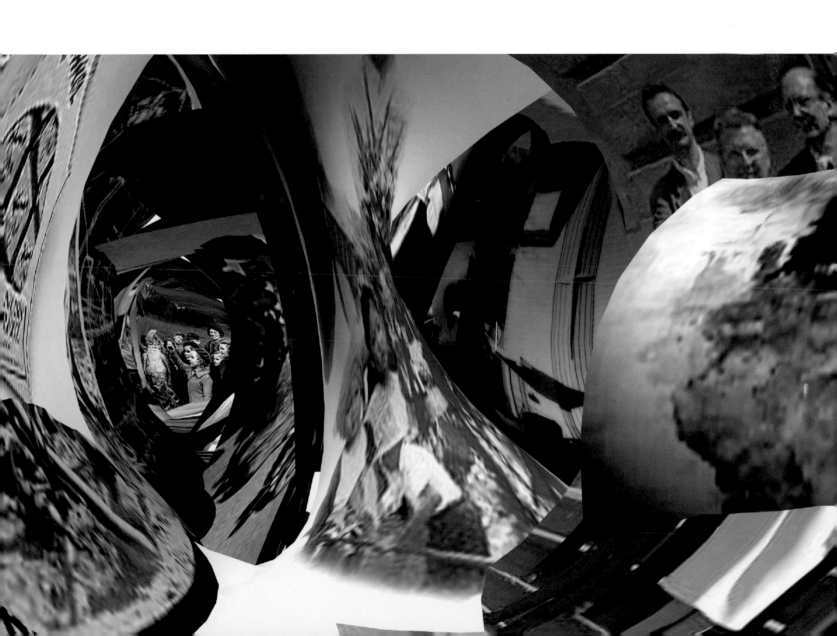

CORY ARCANGEL, *I SHOT ANDY WARHOL*, 2002. REPROGRAMMED NINTENDO CARTRIDGE
Rather than working within the confines of off-the-shelf software, Cory Arcangel writes his own. For *I Shot Andy Warhol*, the artist took a 1980s video game called Hogan's Alley and replaced the original characters with cultural icons. The object of the game is to shoot Andy Warhol and avoid hitting the other characters, who include Pope John Paul II, Flavor Flav of Public Enemy and Colonel Sanders.

KATHLEEN RUIZ, *BANG, BANG (YOU'RE NOT DEAD?)*, 2000. INTERACTIVE MULTI-MEDIA GAME INSTALLATION, 4.6 X 5.5 X 4.9 M (15 X 18 X 16 FT)
Offering an alterative interactive experience to the 'first-person shooter' video game, the goal of *Bang, Bang (you're not dead?)* is to shoot at people who are already dead and resurrect them. The installation includes large images of teenagers playing these video games and confronting each other with fake guns. The total environment encourages the viewer/participant to reflect upon issues of virtual violence, catharsis and desensitization in simulated space.

Opposite
KATHLEEN RUIZ, *STUNT DUMMIES*, 2003. INTERACTIVE MULTI-MEDIA GAME INSTALLATION, 4.6 X 5.5 X 4.9 M (15 X 18 X 16 FT)
Stunt Dummies questions our relationship with video games and technology, and examines the cultural impact of the digital era on our social interactions, ethics and individual identities. This image shows the menu interface of the work, which allows users to explore seven virtual worlds. Kathleen Ruiz drew her inspiration for the interface from the 15th-century painting *The Seven Deadly Sins and the Four Last Things* by Hieronymus Bosch.

THE COMPUTER IS A WONDERFUL FACILITATOR OF CREATIVE THOUGHT. MORE THAN ANYTHING, DIGITAL MEDIA HELPS ME TO EXPLORE THE CONFLUENCE OF THE IMAGINARY AND THE REAL. I WANT THE OBSERVER TO BECOME A PARTICIPANT IN THESE IDEAS, EXPLORING THE PROMISE OF TECHNOLOGY, AS WELL AS ITS FRIGHTENING, FASCINATING AND HUMOROUS CONTRADICTIONS.
KATHLEEN RUIZ

NET ART

While many digital art forms have their roots in traditional media, net art originates from and exists only in the realm of networked media. Text-based artworks have been created since the early days of the internet; however, it was not until the mid-1990s, when graphical browsers such as Mosaic (1993), Netscape Navigator (1994) and Internet Explorer (1995) became widespread, that net art really took hold as a global art form. The nomenclature surrounding this type of art is still evolving, and net art is also referred to as internet art, networked art and web art. There are many kinds of net art: text-based works; politically motivated net activism; browser art; image sites, which include photographs, drawing and digital images; performance; video and audio works; streaming video works based on surveillance; and, more recently, works created using mobile phones, mobile computing and the Global Positioning System (GPS).

One characteristic of net art is its availability to a global audience. It can reach its viewers through sites that use low bandwidth text and graphics – the most reliable way of obtaining the widest possible access – or through ultra-high bandwidth projects that can be seen and experienced in high-end net art centres. Another advantage of net art is the independence it offers artists, who can exhibit their work outside the conventional venues of museum and gallery. They have tremendous freedom to communicate with their audience directly and to do so in an intimate fashion, since the vast majority of net art is experienced by individuals in their homes. Each viewer's physical involvement through the mouse, keyboard and screen also give the medium interactivity.

The growth of net art has been closely linked to the evolution of the internet and its rapidly evolving technology. The initial ARPANET, a communication network commission by the United States Department of Defense and implemented by four universities, remained largely a research tool until Tim Berners-Lee proposed a global project using hypertext: the World Wide Web. The first website was posted in 1991, and the early web continued to be used by educational and research institutions as a free and largely unregulated means of information-sharing.

Early net art included multi-user domains (MUDs) and multi-user object-oriented experiences (MOOs), which consisted of role-playing games and other text-based interactions. As the internet became capable of disseminating images as well as audio and video streaming, net art experienced a parallel growth. One consequence of this rapid evolution

was that a large percentage of early internet art fell victim to browser and software upgrades. The turnaround time for internet software development during the dot.com era of the mid- to late-1990s was as quick as four to six months. Net art projects became obsolete as newer versions of browsers and plug-ins – as well as hardware upgrades – were no longer capable of supporting them. Many museums, non-profit foundations and artists now keep inventories of old computers and discontinued software so that early works can be preserved. New developments in the software emulation of older operating systems and computers can also help to archive these works.

Nettime, founded by Geert Lovink and Pit Schultz in 1995, was established to promote internet culture and criticism, and artists who aided in its formation include Heath Bunting, Vuk Cosic, Jodi, Olia Lialina and Alexei Shulgin. Jodi, the artistic team of Joan Heemskerk and Dirk Paesmans, were well known partially on account of their unique creative work that questioned the fundamental concept of the browser. Around the same time the New York-based Rhizome.org, founded by Mark Tribe, offered an open forum for discussion on net art and also developed an archive. The Walker Art Center Net Art Initiative, founded by Steve Deitz in Minneapolis, was very influential in supporting net art, hosting an important collection and a series of online exhibitions. A number of museum websites, such as the Whitney Museum of American Art Artport, the Solomon R. Guggenheim Museum and the San Francisco Museum of Modern Art, also became net art advocates.

Video-based interaction on the internet began with CUseeMe and MBONE, the video conferencing software that spawned performance-based pieces and other interactive net video works. Since then, video projects – both interactive and linear – have developed rapidly on the web, although they are heavily dependent on ample bandwidth for their success. Currently, organizations such as La Société des Arts Technologiques (SAT) in Montreal and MARCEL, founded by Don Foresta in France, are working with ultra-high bandwidth applications for creative purposes, using networks such as Access Grid (AG), Internet2 and National LambdaRail (NLR).

The advent of wireless technology now allows net artists creative possibilities using mobile handheld devices such as PDAs and mobile phones. Golan Levin's groundbreaking *DIALTONES (A Telesymphony)* at Ars Electronica in 2001 was a concert performed entirely through the ringing of the audience's mobile phones. The Global Positioning System pinpoints the exact position of the viewer through satellite communications. Art projects that use this technology are GPS Drawing, the C5 Landscape Initiative and the Amsterdam RealTime Project. GPS has expanded the definition of net art beyond wired networks, harkening back to the first wireless technology – radio – while looking forward to the wireless environments of the future.

Many museums now have their own net art websites and also commission works for exhibition. The debate as to whether or not net art can be successfully exhibited in museums and galleries is ongoing. Exhibited works that have received wide critical acclaim are Jodi's gallery installations and Wolfgang Staehle's *Empire 24/7*, a time-based work featuring a

Above left
JODI, *UNTITLED GAME*, 2000. 13 MODIFICATIONS OF QUAKE 1
Above right
JODI, *CTRL-SPACE*, 1998. MULTI-PLAYER MODIFICATION OF QUAKE 1
Opposite
JODI, *MY%DESKTOP*, 2003. INSTALLATION WITH 4 PROJECTIONS

Joan Heemskerk and Dirk Paesmans, the creative team of Jodi, are perhaps the best known pioneers of net art. From an artistic background that includes photography, video and performance, Jodi produce net art that emulates and comments on technological malfunction: viruses, error messages and computer crashes that turn computer screens into an array of abstract animation and imagery. Their work, often described as technological abstraction, subverts the normal process of navigation with a mouse and keyboard and the traditional interface between human and computer. Their digital artworks have also been presented as CD-ROMs, games and gallery installations.

IT IS OBVIOUS THAT OUR WORK FIGHTS AGAINST HIGH TECH. WE ALSO BATTLE WITH THE COMPUTER ON A GRAPHIC LEVEL. WHEN A VIEWER LOOKS AT OUR WORK, WE ARE INSIDE HIS COMPUTER. YOU ARE VERY CLOSE TO A PERSON WHEN YOU ARE ON HIS OR HER DESKTOP. I THINK THE COMPUTER IS A DEVICE TO GET INTO SOMEONE'S MIND. WE REPLACE THIS MYTHOLOGICAL NOTION OF A VIRTUAL SOCIETY ON THE NET OR WHATEVER WITH OUR OWN WORK. WE PUT OUR OWN PERSONALITY THERE.
JODI

I DECIDED TO PUT UP A QUESTIONNAIRE ASKING PEOPLE WHAT KIND OF BODY THEY WOULD LIKE TO HAVE. TO MY SURPRISE, THOUSANDS OF PEOPLE RESPONDED AND WERE ACTUALLY AWAITING THEIR BODIES. THIS LED ME TO CONSIDER THE MEANING OF OUR PERSONIFICATION OF THE WEB, THE RESULTING DATABASES FILLED WITH OUR INFORMATION AND THE NEED TO VISUALIZE OUR VIRTUAL BODIES. I WAS ALSO QUESTIONING THE RHETORIC OF THE TIME, WHICH PROMOTED THE INTERNET AS THE ULTIMATE DEMOCRATIC SPACE.
VICTORIA VESNA

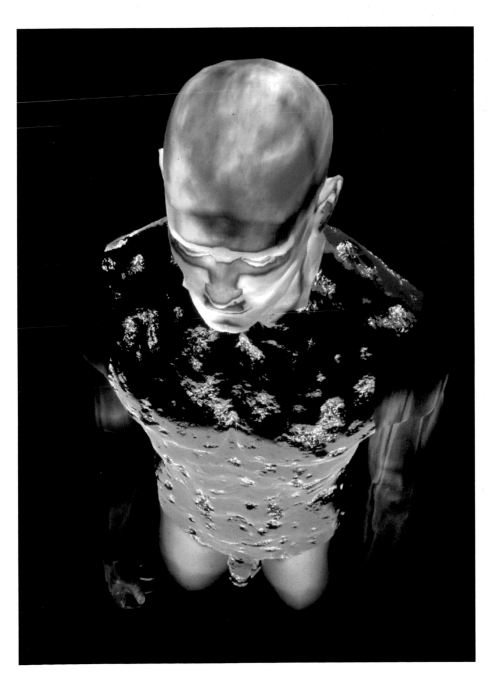

VICTORIA VESNA, *BODIES© INCORPORATED*, 1996. COLLABORATIVE ONLINE PROJECT
Victoria Vesna became involved in net art soon after its emergence. *Bodies© INCorporated* – perhaps one of longest-running net art projects – explores the creation of, and our relationship with, our online alter egos. The website invites participants to assemble a 3D body online: after logging on, the user can design, edit, render and download a virtual body image. Part of the website allows online chat among participants, while another link provides a catalogue of rendered bodies or electronic identities

A TIMELINE OF DIGITAL ART AND TECHNOLOGY

PRE-DIGITAL PRECEDENTS

1450 Gutenberg invents movable type and the printing press.

1868 The typewriter is designed by Christopher Sholes and built by Remington in 1874.

1876 The telephone is invented by Alexander Graham Bell.

1877 Thomas Edison develops the phonograph.

1887 Motion picture camera patented by Thomas Edison.

1888 Eadweard Muybridge publishes his series of photographs, *Studies of Animal Locomotion*.

1895 Louis and Auguste Lumière produce two of the earliest motion pictures, *Workers Leaving the Lumière Factory in Lyon* and *A Trip to the Moon* in 1902.

1901 Guglielmo Marconi transmits Morse code across the Atlantic Ocean and ushers in the age of radio.

1920 Léon Theremin creates an electronic musical instrument based on an oscillating circuit, the Theremin, which is controlled by hand gestures.

1927 The first television picture is transmitted by Philo Farnsworth.

1931 The first stereo recordings are made.

1939 Television debuts at the New York World's Fair.

1939– John Cage creates *Imaginary Landscapes*,
1952 a series of early electronic music works and performances.

THE DIGITAL AGE

1946 ENIAC, one of the first computers, is built using 18,000 vacuum tubes.

1950s SAGE Air Defense computers convert radar signals into computer graphic images. The light pen is introduced.

1950 Ben Laposky uses oscilloscopes to display waveform patterns that are photographed and exhibited.

1963 American Standard Code for Information Interchange (ASCII) is adopted as a standard for computer text.

1963 Mellotron instrument is invented, which uses tape loops to create its sound.

1963 First computer graphics software is created by Ivan Sutherland at MIT called Sketchpad.

1963 Lapis film is produced by John Whitney, Sr.

1963 Nam Jun Paik exhibits *Random Access*, using strips of magnetic tape and tape heads that gallery attendees swipe to produce sounds.

1964 Stan Vanderbeek and Ken Knowlton produce the computer-animated film, *Poem Field*.

1965 First computer art exhibition at the Technische Hochschule in Stuttgart, Germany.

1965 Early computer art exhibitions at the Technische Hochschule in Stuttgart, Germany and the Howard Wise Gallery in New York.

1965 Stereo computer animations are created by A. Michael Noll and Bela Julesz at Bell Labs in New Jersey.

1966 Billy Klüver starts Experiments in Art and Technology (EAT).

1966 Charles A. Csuri produces the computer-animated film, *Hummingbird*, which is later purchased by MoMA.

1968 The mouse is invented by Douglas Englebart.

1968 John Whitney, Sr. creates the computer-animated film, *Permutations*.

1968 One of the first computer art exhibitions, 'Cybernetic Serendipity: the Computer and the Arts' held at the Institute of Contemporary Arts (ICA) in London.

1968 'Machine As Seen at the End of the Mechanical Age' exhibition is held at the Museum of Modern Art in New York.

1968 *Leonardo* journal is first published in Paris by founder Frank J. Malina.

1969 Myron Kreuger develops one of the first prototypes of virtual reality.

1969 ARPANET is set up by the United States Department of Defense.

1969 The first frame buffer is developed by Bell Labs, which allows the storage of a single digital image.

1969 The Studio for Electro-Instrumental Music (STEIM) is established in Amsterdam.

1970 Xerox established the Palo Alto Research Center (PARC) at Stanford University.

1970 The first high definition colour computer graphic workstation, Genigraphics, is created by General Electric.

1970 *Expanded Cinema*, written by Gene Youngblood is published.

1973 ACM SIGGRAPH, the special interest group in graphics established.

1974 *Hunger*, an early computer animated film by Peter Foldes is produced at the National Film Board of Canada.

1975 Benoit Mandelbrot develops fractals at IBM.

1976 Franklin Furnace is founded by Martha Wilson in New York.

1977 The Apple II computer becomes the first personal computer with colour graphics.

1977 Institut de Recherche et Coordination Acoustique/Musique (IRCAM) is established in France.

1977 *Satellite Arts Project* by Kit Galloway and Sherrie Rabinowitz.

1979 The Fairlight Computer Musical Instrument CMI is invented. It is the first digital music synthesizer.

1979 The Modulator/Demodulator or MODEM is invented, allowing digital signals to travel over analogue phone lines.

1979 Ars Electronica Festival started in Linz, Austria.

1979 *Lorna*, one of the first videodisks by an artist created by Lynn Hershman Leeson.

1980 The MIT Media Laboratory is founded by Nicholas Negroponte.

1981 IBM releases their first PC computer.

1982 *The World in 24 Hours*, one of the first global telecommunications art events, is produced by Robert Adrian.

1982 Adobe Systems is founded.

1982 International Society for the Arts, Sciences and Technology (Leonardo/ISAST) is founded by Roger F. Malina.

1983 The compact disk (CD) is introduced.

1983 *Growth*, the first in a series of computer animations is created by Yoichiro Kawaguchi.

1984 Musical Instrument Digital Interface (MIDI) is established, which enables digital synthesizers from different manufacturers to communicate with each other

1984 The first Macintosh computer is released.

1984 Kit Galloway and Sherrie Rabinowitz co-found the Electronic Cafe.

1985 AT&T develops the TARGA 16 graphic card, allowing for 16-bit images and 32,000 colours.

1986 DAT or digital audio tape is introduced by Sony/Phillips.

1986 Nicolas Schöffer receives the Frank J. Malina Lifetime Achievement Award.

1986 *Very Nervous System* created by David Rokeby.

1987 First Master of Fine Arts degree programme in Computer Art in the United States started at the School of Visual Arts in New York.

1987 Prix Ars Electronic is established to recognize significant achievements in cyberarts.

1988 The Renderman shading language is released by Pixar and received a US patent.

1988 Australian Network for Art and Technology (ANAT) is established.

1988 Art Science Collaborations Inc. (ASCI) is founded by Cynthia Pannucci to support technology-based art.

1989 Jeffrey Shaw creates an interactive work, *The Legible City*.

1990 Karl Sims produces *Panspermia*, one of the first computer animations to be produced by a single individual.

1990 Kenneth Snelson creates some of the first virtual sculptures using 3D software.

1991 William Latham at IBM UK produces the computer animation, *Mutations*.

1991 James F. Blinn is named a MacArthur Fellow for his pioneering work in computer animation.

1991 The MP3 digital audio compression format is developed at the Fraunhofer Institute, Germany.

1991 The Thing, a bulletin board service focusing on contemporary art and cultural theory is launched in New York.

1992 HyperText Markup Language (HTML) is developed for the internet, paving the way for the World Wide Web.

1993 The first New York Digital Salon is held at the Art Directors Club in New York.

1993 Mosaic, the first graphical web browser is released.

1993 Karl Sims creates a series of software-based works, *Genetic Images*

1994 The Netscape browser is introduced.

1994 *A-Volve*, the interactive real-time environment, is created by Christa Sommerer and Laurent Mignonneau.

1994 Electronic Music Foundation established by Joel Chadabe.

1995 RealAudio standard is introduced which allows for streaming data over the internet. RealVideo is introduced shortly after.

1995 Nettime founded to promote international networked discourse.

1995 *Osmose*, an immersive interactive virtual reality environment is created by Char Davies.

1996 Benjamin Weil, Vivian Selbo and Andrea Scott found äda'web, a multi-artist net art project.

1996 DVD video is introduced.

1996 Eyebeam is founded by John S. Johnson in New York.

1996 Rhizome.org founded to provide a platform for the global new media community.

1996 Postmasters Gallery in New York starts promoting digital art with the exhibition 'Can You Digit?'

1997 MP3.com is founded by Michael Robertson.

1997 'Digital Atelier: A Printmaking Studio for the 21st Century' at the Smithsonian Museum of American Art is organized by Dorothy Simpson Krause.

1997 Steve Dietz establishes Gallery 9, a net art gallery at the Walker Art Center.

1998 Char Davies creates the 3D virtual reality immersive environment *Ephémère*.

1998 Karl Sims is named a MacArthur Fellow in digital art and computer science.

1999 Paul Debevec uses image-based rendering to produce the animation, *Fiat Lux*.

1999 The first recordable CD-ROM is developed by Sony and Phillips.

1999 Vectorial Elevation by Rafael Lozano-Hemmer allows internet users to control a light installation in Mexico City.

1999 *Glasbead*, an interactive music work, is created by John Klima.

2000 Jodi creates www.jodi.org, one of best-known net art websites.

2000 DVD becomes the best-selling technology ever.

2000 The Digital Art Museum (DAM) in Berlin becomes an online digital art museum.

2001 San Francisco MoMA exhibits '010101: Art in Technological Times'.

2001 The Whitney Museum of American Art presents the 'BitStreams' and 'Data Dynamics' exhibitions.

2001 Brooklyn Museum opens the 'Digital Printmaking' exhibition.

2001 DA2, digital arts development agency is established in the UK.

2001 Alexander R. Galloway and the Radical Software Group create Carnivore software.

2001 Erwin Redl's *Matrix IV* is exhibited at the Whitney Museum in New York.

2001 *Pockets Full of Memories* installation is created by George Legrady.

2001 Martin Wattenberg and Marek Walczak create the net art piece, *The Apartment*.

2001 'Game Show' exhibition at the Massachusetts Museum of Contemporary Art.

2001 Apple Computer, Inc. releases the iPod digital music player.

2001 Bitforms Gallery, featuring digital art, opens in New York.

2002 DigiArts website is added to the UNESCO Knowledge Portal.

2002 Whitney Museum of American Art portal to net art and digital art, ARTPORT, is launched.

2002 'INSTALL.EXE', the first United States solo exhibition by Jodi at Eyebeam.

2003 New York Digital Salon celebrates its 10th anniversary with 'VECTORS: Digital Art of Our Time exhibition at the World Financial Center in New York City'.

2003 ACM SIGGRAPH Art Gallery celebrates its 30th anniversary.

2003 Jeremy Gardiner wins the Peterborough Art Prize for *Purbeck Light Years*.

2003 'NANO' exhibition by Victoria Vesna, James Gimzewski and others begins at Los Angeles County Museum of Art.

2004 First Beijing International New Media Arts Exhibition and Symposium.

2004 Chris Landreth wins the Academy Award for Best Animated Short Film with *Ryan*.

2004 *Vectorial Elevation* by Rafael Lozano-Hemmer is installed in Dublin, Ireland.

2005 Vera Molnar receives the first lifetime achievement d.velop digital art award (ddaa).

2005 The Boston Cyberarts Festival celebrates the use of technology in the arts.

2006 Inter-Society for Electronic Arts (ISEA) Pacific Rim New Media Summit is held.

2006 New York Digital Salon debuts the Abstract Visual Music website, exhibition and events.

2006 NODE.London, media art festival begins.

ARTISTS' WEBSITES

Further information on the artists and artworks included in this book can be found on the websites that follow. An online list is also available on the Thames & Hudson website for this book:
http://www.thamesandhudson.com/en/1/0500238170.mxs

Abahuni, Leesa & Nicole
http://www.abahuni.org
Acevedo, Victor
http://www.acevedomedia.com
Anderson, Victor
http://www.go.to/victoranderson
Anker, Suzanne
http://www.geneculture.org
Arcangel, Cory
http://www.beigerecords.com/cory
Ashford, Rain Anne
http://www.twinkly.tv

Beasley, Bruce
http://www.brucebeasley.com
Bowen, Robert
http://www.bowenstudio.com
Briand, Mathieu
http://www.mathieubriand.com
Brown, Paul
http://www.paul-brown.com

Campbell, Jim
http://www.jimcampbell.tv
Casado, José Carlos
http://www.josecarloscasado.com
Chan, Clara
http://www-viz.tamu.edu/showcase/thswkimg
/c_chan/index.html
Collins, Dan
http://www.asu.edu/cfa/art/people/faculty/c
ollins
Collopy, Fred
http://www.rhythmiclight.com
Condon, Brody
http://www.tmpspace.com
Csuri, Charles A.
http://www.csurivision.com
Cuba, Larry
http://www.well.com/user/cuba

Davies, Char
http://www.immersence.com

Deck, Andy
http://artcontext.net
http://andyland.net
Doherty, Robin
http://www.arraystudios.co.uk
Domingues, Diana
http://artecno.ucs.br
Dove, Toni
http://www.tonidove.com

Eber, Dena Elisabeth
http://art.bgsu.edu
Em, David
http://www.davidem.com
Epuré, Sherban
http://www.serban-epure-letitzia-bucur.com

Farkas, Tamás F.
http://www.geocities.com/tamasffarkas/1.html
Fenster, Diane
http://www.dianefenster.com
Field, Michael
http://nothung.math.uh.edu/~mike
Finnegan, John Campbell
http://www.tech.purdue.edu/newalbany/facult
yandstaff/fac_finnegan.cfm
Fisher, Rob
http://robfisheramericandream.com
http://www.sculpture.org/robfisher
Fry, Benjamin
http://acg.media.mit.edu/people/fry/
valence
Fujihata, Masaki
http://www.fujihata.jp

Galloway, Alexander R.
http://itserve.cc.ed.nyu.edu/galloway
Galloway, Kit
http://www.ecafe.com
Gardiner, Jeremy
http://www.jeremygardiner.co.uk
Gartel, Laurence
http://www.gartelmuseum.com

Geib, Dona
http://www.clevelandart.org/private/tas/html/
2744775.html
Goldberg, Ken
http://www.ken.goldberg.net
Golden, Helen
http://www.helengolden.com
Gollifer, Sue
http://dam.org/gollifer

Haig, Ian
http://www.ianhaig.net
Hébert, Jean-Pierre
http://jeanpierrehebert.com
Hong, Wonhwa
http://www.koreanculture.org/09gallery/archi
ve2002poetry.htm
Huang, Shih-Chieh
http://www.nyfa.org/nyfa_artists_detail.asp?pi
d=36
Huff, Kenneth A.
http://www.itgoesboing.com

Iwai, Toshio
http://ns05.iamas.ac.jp/~iwai/iwai_main.html

Jodi
http://www.jodi.org
Johnson, Chris S.
http://www.csj2.com
Jones, Bill
http://firstpulseprojects.com/bill.html

Kac, Eduardo
http://www.ekac.org
Kawaguchi, Yoichiro
http://www.iii.u-tokyo.ac.jp/~yoichiro
Kerlow, Isaac
http://www.artof3d.com/kerlow.htm
Klima, John
http://www.glasbead.com
Knowlton, Ken
http://www.knowltonmosaics.com

IMAGE CREDITS

Images are referred to by page number.
All images are copyright the artist unless otherwise stated.

130 Juan Antonio Lleó, *Torre de Espejos
(Tower of Mirrors)*, 2003.
131 Juan Antonio Lleó, *Midiverso*, 1994–2000.
132 John Klima, *Glasbead*, 1999.
133 (l) Joan La Barbara, Golan Levin,
Zach Lieberman and Jaap Blonk,
Messa di Voce, 2003.
Photo: Golan Levin.
133 (r) Joan La Barbara, Golan Levin,
Zach Lieberman and Jaap Blonk,
Messa di Voce, 2003.
Photo: Golan Levin.
134 (l) Leesa and Nicole Abahuni, *Capacitance*, 2003.
Commissioned by the Department of Culture and
Information of Sharjah, United Arab Emirates,
under the direction of His Highness Sheikh Sultan
bin Muhammed Al Qasimi, Ruler of Sharjah.
134 (r) Leesa and Nicole Abahuni, *Chaotic Robotic
Synesthesia*, 2000.
Support from the Experimental Television Center,
Oswego, NY.
135 Rain Anne Ashford, *Dustharps*, 2000.
136 Fred Collopy, *PhiSpirals*, 2004.
137 Fred Collopy, *Wood & Water*, 2004.
138 (l) Atau Tanaka and Kasper Toeplitz,
Global String, 2000.
Produced with financial assistance from
the Daniel Langlois Foundation for Art,
Science and Technology.
138 (r) Atau Tanaka and Kasper Toeplitz,
Global String, 2000.
Photo: Gerda Seebacher.
Produced with financial assistance from
the Daniel Langlois Foundation for Art,
Science and Technology.
139 Peter Terezakis, *L'Autre (The Other)*, 1996.
Courtesy of Peter Terezakis.
140 Stephen Vitiello, *World Trade Center
Recordings: Winds After Hurricane Floyd*,
1999. Photo: Johnna MacArthur. Courtesy
of The Project, New York and
Los Angeles.
141 Stephen Vitiello, *Frogs in Feedback*, 2002.
Private collection, London.

CHAPTER 6:
DIGITAL ANIMATION AND VIDEO
145 Clara Chan, *Autumn Bamboo*, 2000. This piece
was created with the guidance of Prof. Carol
LaFayette.
146 (a) Jim Campbell, *Church on Fifth Avenue*, 2001.
146 (b) Jim Campbell, *Motion and Rest #5 (white)*,
2002.
147 Cory Arcangel, *Urbandale Still*, 2001.
Urbandale is a commission of New Radio and
Performing Arts, made possible with funding
from the Jerome Foundation.
148 Larry Cuba, *3/78
(Objects and Transformations)*, 1978.
149 Larry Cuba, *Two Space*, 1979.
150 Toni Dove, *Spectropia Conjures Sally* from
Spectropia, 1999–2002.
Written, designed and directed by Toni Dove.
Actress: Aleska Palladino.
151 (a) Toni Dove, *Sally's Dressing Room* from *Sally

or The Bubble Burst*, 2003.
Written, designed and directed by Toni Dove.
Actress: Helen Pickett.
151 (b) Toni Dove, *Sally's Bubble Dance* from *Sally or
The Bubble Burst*, 2003.
Written, designed and directed by Toni Dove.
Actress: Helen Pickett.
152 (l) Yoichiro Kawaguchi, *Nebular*, 2000.
152 (r) Yoichiro Kawaguchi,
Artificial Life Metropolis Cell, 1993.
153 Yoichiro Kawaguchi, *Topolon*, 2001.
154 Dennis H. Miller, *Faktura 2*, 2003.
Courtesy of Dennis H. Miller,
Northeastern University.
155 Dennis H. Miller, *Vis a Vis*, 2002.
Courtesy of Dennis H. Miller,
Northeastern University.
156 (l) Wayne Lytle, *Pipe Dream*
from *Animusic*, 2001.
Courtesy of Wayne Lytle.
156 (r) Wayne Lytle, *Harmonic Voltage* from
Animusic, 2001.
Courtesy of Wayne Lytle.
157 Wayne Lytle, *Acoustic Curves*
from *Animusic*, 2001.
Courtesy of Wayne Lytle.
158 (l) Muntadas, *THIS IS NOT AN
ADVERTISEMENT*, 1985.
Courtesy of Muntadas.
158 (r) Muntadas, *'SPEED'* from *THIS IS NOT AN
ADVERTISEMENT*, 1985.
Courtesy of Muntadas.
172 Karl Sims, *Particle Dreams*, 1988.
Courtesy of Karl Sims.
160 (al) Karl Sims, *Panspermia*, 1990.
Courtesy of Karl Sims.
160 (ar) Karl Sims, *Panspermia*, 1990.
Courtesy of Karl Sims.
160 (bl) Karl Sims, *Panspermia*, 1990.
Courtesy of Karl Sims.
161 Karl Sims, *Panspermia*, 1990.
Courtesy of Karl Sims.
162 Opy Zouni, *Art and Industrial Product*, 2004.
163 (a) Opy Zouni, *Light/Shadow/Coincidences*,
1999.
163 (b) Opy Zouni, *Art and Car*, 2003.

CHAPTER 7:
SOFTWARE, DATABASE AND GAME ART
167 Lynn Hershman Leeson, *Synthia*, 2000–02,
Artist: Lynn Hershman Leeson in cooperation with
Lior Saar.
Fabricator: Matt Heckert.
Administrator: Michael Ahearn.
Coordinator: Kyle Stephan.
Web design and production:
Sandra D. Zimmermann, Berlin.
Designers: Sean Ahlquist, Matt Whitman,
Ben de Leon and Digital Core.
Additional software: Michael Greenspon,
Sequin Corporation. Collection of Donald Hess.
168 Alexander R. Galloway and RSG,
CarnivorePE, 2001.
Courtesy of Alexander R. Galloway.
169 Russet Lederman, *American Views: Stories of

the Landscape*, 2001.
Commissioned by the Smithsonian American
Art Museum.
169 Josh On, *They Rule*, 2001.
Artwork map created by Chris MacGregor.
170 (a) John F. Simon, Jr., *Color Panel v1.0*, 1999.
Courtesy of John F. Simon, Jr.
170 (b) John F. Simon, Jr., *ComplexCity*, 2000.
Courtesy of John F. Simon, Jr.
171 John F. Simon, Jr., *Every Icon*, 1996.
Courtesy of John F. Simon, Jr.
172 Golan Levin, *Floccus*, 1999.
Courtesy of Golan Levin.
172 Golan Levin, *Yellowtail*, 1999.
Courtesy of Golan Levin.
173 Golan Levin, Scott Gibbons and Gregory
Shakar, *Scribble*, 2000.
Courtesy of Golan Levin.
174 Michael Field, *Armies of the Night*, 2000.
175 George Legrady, *Pockets Full of Memories*,
2001. (Interactive installation.)
Produced in collaboration with Dr Timo Honkela,
Media Lab, University of Art and Design
Helsinki, (Kohonen self-organizing neural-net
algorithm); C3 Center for Culture and
Communication, Budapest (touchscreen data
collection, hardware and software);
Projekttriangle, Stuttgart, (design and visual
identity); Andreas Schlegel, (visualization
programming); CREATE lab, UC Santa Barbara,
(web software development). With the financial
assistance of the Daniel Langlois Foundation for
Art, Science and Technology, Montreal; Centre
Georges Pompidou, Paris; and the Office of
Research, UC Santa Barbara.
176 George Legrady, *Contributed Objects, Pockets
Full of Memories* (Data Visualization), 2001.
See 191.
178 Marek Walczak and Martin Wattenberg,
Apartment, 2001.
Courtesy of Marek Walczak and Martin
Wattenberg.
179 Marek Walczak and Martin Wattenberg,
Apartment, 2001.
Courtesy of Marek Walczak and Martin
Wattenberg.
180 (l) Cory Arcangel, *I Shot Andy Warhol*, 2002.
Courtesy of Team Gallery and the Beige
Programming Ensemble.
180 (r) Cory Arcangel, *I Shot Andy Warhol*, 2002.
Courtesy of Team Gallery and the Beige
Programming Ensemble.
180 Kathleen Ruiz, *Bang, Bang (you're not dead?)*,
2000.
181 Kathleen Ruiz, *Stunt Dummies*, 2003:
182 W. Bradford Paley, *TextArc*, 2002.
Courtesy of W. Bradford Paley.

CHAPTER 8:
NET ART
188 (l) Jodi, *Untitled Game*, 2000.
Courtesy of the %20 Artist.
188 (r) Jodi, *CTRL-SPACE*, 1998.
Courtesy of the %20 Artist.
189 Jodi, *My%Desktop*, 2003.

Courtesy of the %20 Artist.

190 (a) Ken Goldberg, *Telegarden*, 1995–2004.
Co-directors: Ken Goldberg and
Joseph Santarromana.
Project team: George Bekey, Steven Gentner,
Rosemary Morris Carl Sutter, Jeff Wiegley,
Erich Berger.
Photo: Robert Wedemeyer.

190 (b) Ken Goldberg, Randall Packer,
Gregory Kuhn and Wojciech Matusik,
Mori, 1999– present.
Concept and direction: Ken Goldberg.
Sound composition and design: Randall Packer.
Physical and acoustical design: Gregory Kuhn.
Internet and display software: Wojciech Matusik.
Thanks to Berkeley Seismographic Lab (Lind
Gee, Doug Neuhouser, Barbara Romanowicz).
Live seismic data feed: NTT InterCommunication
Center and support for Version 1.0.
Sound System: Meyer Sound Laboratories.
Software Support: CNMAT, UC Berkeley.
Builder: Pamela Beitz. Production: Zakros
InterArts. Curation: Steve Dietz.

191 (a) Lynn Hershman Leeson, *Agent Ruby's
Edream Portal*, 2002.
Courtesy of Bitforms Gallery, New York, NY
and Gallery Paule Anglim, San Francisco, CA.

191 (b) Lynn Hershman Leeson, *Agent Ruby Mood
Swing Diagram*, 2002.
Courtesy of Bitforms Gallery, New York, NY
and Gallery Paule Anglim, San Francisco, CA.

192 Victoria Vesna, *Bodies© INCorporated*,
1996 (4 views).
Produced in collaboration with Jason Schleifer,
Ken Fields and Robert Nideffer.

193 Victoria Vesna, *Bodies© INCorporated*, 1996.
Produced in collaboration with Jason Schleifer,
Ken Fields and Robert Nideffer.

194 Diana Domingues, *Serpentarium*, 2000.
Produced by Diana Domingues/ARTECHNO
Group. NTAV laboratory of Research: New
Technologies in Visual Arts, University of Caxias
do Sul/CNPq, Brazil.
Thanks to CNPq-Conselho Nacional de
Desenvolvimento Cientifico e Tecnologico;
FAPERGS-Fundacao de Amparo à Pesquisa do
Estado do Rio Grande do Sul; UCS Universidade
de Caxias do Sul.

195 Diana Domingues, *I N S N (H) A K (R) E S*,
2000–01.
Produced by Diana Domingues/ARTECHNO
Group. NTAV laboratory of Research: New
Technologies in Visual Arts, University of Caxias
do Sul/CNPq, Brazil.
Thanks to CNPq-Conselho Nacional de
Desenvolvimento Cientifico e Tecnologico;
FAPERGS-Fundacao de Amparo à Pesquisa do
Estado do Rio Grande do Sul; UCS Universidade
de Caxias do Sul.

197 Andy Deck, *Glyphiti*, 2001 – present.
Frame from 8 August 2003.
Courtesy of artcontext.net.

198 (l) Muntadas, *The File Room*, 1994.
Courtesy of Muntadas.

198 (r) Muntadas, *On Translation:
The Internet Project*, 1996.
Courtesy of Muntadas.

199 Patrick Lichty, *Sprawl*, 2000.
Courtesy of Patrick Lichty.

200 Maciej Wisniewski, *3 Seconds in the Memory
of the Internet*, 2002.
Courtesy of Postmasters Gallery, New York, NY.

201 Maciej Wisniewski, *netomat™*, 1999.
Courtesy of Postmasters Gallery, New York, NY.

201 Adrianne Wortzel, *Dream Sequence* from
Eliza Redux, 2004.
Developed at StudioBlue, the Cooper Union for
the Advancement of Science and Art, New York,
with support from a Franklin Furnace Fund for
Performance Art Grant.

202 Alexander R. Galloway, Mark Tribe and Martin
Wattenberg, *StarryNight*, 1999.

203 (a) Annette Weintraub, *Life Support (patient
room)*, 2003.

203 (b) Annette Weintraub, *Life Support (surgery)*,
2003.

204 (l) Rafael Lozano-Hemmer, *Vectorial Elevation,
Relational Architecture 4*, 1999–2004.

204 (r) Rafael Lozano-Hemmer, *Vectorial Elevation,
Relational Architecture 4*, 1999–2004.

205 Rafael Lozano-Hemmer, *Vectorial Elevation,
Relational Architecture 4*, 1999–2004.
Photo: Martin Vargas.

INDEX